THIS
IS
MODERN
ART

Idris Goodwin
and Kevin Coval
based on real events

Haymarket Books
Chicago, Illinois

Published in 2016 by
Haymarket Books
P.O. Box 180165
Chicago, IL 60618
773-583-7884
www.haymarketbooks.org
info@haymarketbooks.org

ISBN: 978-1-60846-597-2

Trade distribution:
In the US, Consortium Book Sales and Distribution, www.cbsd.com
In Canada, Publishers Group Canada, www.pgcbooks.ca
In the UK, Turnaround Publisher Services, www.turnaround-uk.com
All other countries, Publishers Group Worldwide, www.pgw.com

This book was published with the generous support of Wallace Action
Fund and Lannan Foundation.

Cover design by Eric Kerl and Jamie Kerry. Cover and interior photos
by Kevin Coval.

Printed in Canada by union labor.

Library of Congress Cataloging-in-Publication data is available.

This work was commissioned by Steppenwolf Theater for Young Audiences.
It was developed at New Voices/New Visions at The Kennedy Center in 2014.

All inquires concerning rights to produce *This Is Modern Art*, including
amateur rights, should be addressed to: Playscripts, Inc., 7 Penn Plaza,
Suite 904, New York, NY 10001, www.playscripts.com.

10 9 8 7 6 5 4 3 2 1

Contents

Foreword

This Is Modern Art is a play about a crime committed on February 21, 2010, when a graffiti crew bombed the Renzo Piano Modern Wing of the Art Institute of Chicago. The play is about more than just this particular art crime, however. It is also about an ongoing kind of crime perpetrated by the powerful against those in the margins, a more universal history of oppression that takes place through the prescription of what is beautiful.

The so-called crime that occurred on February 21, 2010, was visible for a few short hours and carried a steep monetary fine and prison terms, and it forced four young people to go underground and become fugitives. The more pervasive crime has been carried out with impunity for more than a century by our most celebrated cultural institutions and will never be tried in any court of law. In fact, the idea that an elite sector of society is empowered to decide what is considered art, and therefore what deserves to be valued, collected and preserved in museums on behalf of us all, is a widely accepted norm.

This Is Modern Art asks a lot from the reader/audience. It asks us to be outraged by this contradiction and to be willing to ask some difficult questions about the relationship between truth, justice and beauty: Who gets to define what counts as art, and who are always the winners and losers in this decision?

When I refer to the margins, I am thinking of bell hooks and her description of the margins as a space where people of color have always been forced to create freedom. The play explores these margins to tell the subterranean history of graffiti so that we can see it, *really see it*, as an art movement, as a mode of survival and resistance, and as an act of rebellion and revolution. In this way, *This Is Modern Art* presents graffiti as a diasporic art form— much like the blues or jazz. The Greek word "diaspora" is a combination of "dia-"– (meaning "through") and the verb "sperein" ("to sow" or "to scatter"). When one refers to the African Diaspora, it is usually a reference to the aftermath of transatlantic slavery that began in the fifteenth century and continued for almost four centuries.[1] Slave traders "scattered" more than eleven million Africans throughout the Americas, Europe, and Asia. An estimated two million Africans also died en route. *This Is Modern Art* describes the context for the modern diaspora that is an enduring consequence of racial slavery and continues to displace people of color and disrupt cultural communities—urban gentrification. We come to see the bleak underlying causes that create the conditions for graffiti: the failing infrastructures of cities, disinvestment in communities of color, white flight to the suburbs as they become a new middle-class ideal, the surveillance and criminalization of youth of color, and the abuse of power by the police. These causes have all contributed to a new forced mass migration that is taking place across the United States; hundreds of thousands of black people have been moved from neighborhoods with long histories as centers of African-American life, including neighborhoods in Chicago, Oakland, Washington, New Orleans, and Detroit. According to a recent census report,

1 See George Shepperson, "African Diaspora: Concept and Content," in *Global Dimensions of the African Diaspora*, ed. Joseph Harris (Washington, DC: Howard University Press, 1982), 52.

Chicago's population fell by 200,418 from 2000 to 2010, and African Americans accounted for almost 89% of that drop.[2] To recognize graffiti as a diasporic art form is to insist that graffiti is not an individual act of vandalism and that it is much more than an individual act of creative expression. Instead graffiti should be acknowledged as an expansive culture of visual representation, with skills and techniques, tropes and practices by which diverse artists affected by transatlantic slavery, urban gentrification and its aftermaths have come to think of themselves through loss and hope as connected to one another. Through these forms of shared cultural expression, political views, past experiences, and imagined futures, graffiti is a critical part of an ongoing process by which individuals forge and express a sense of community.[3]

This Is Modern Art is a play that asks a lot from the audience/reader. The play asks us to admit we are illiterate when it comes to graffiti—ignorant of its history, politics, and poetics—and that we need to be schooled. Without this background, graffiti is illegible. And to this end, the play is instructive, but also revelatory. Some works of graffiti function as informal popular education, a kind of public commentary and critique that can be easily read by as many people as possible. For example, the word "STOLEN" spray painted in large red letters across a building that used to be affordable housing and is now in the process of becoming so-called "luxury lofts" is a lesson about urban renewal and gentrification. This one-word art crime speaks truth to power and conjures a feeling about what is happening in our cities more powerfully, and certainly more succinctly, than any policy analysis ever could.

However, for the most part, in order to decode the tags, make sense of the exuberance of wildstyle or bubble letters, interpret the shout-outs found in pieces and throwups, an expansive visual and cultural literacy is actually necessary. And while *This Is Modern Art* attempts to make graffiti more legible for us on the outside, the play also makes it clear that we will never truly

2 See http://usatoday30.usatoday.com/news/nation/census/2011-05 -20-chicago-blacks-exodus_n.htm

3 See Stuart Hall, "Cultural Identity and Diaspora," in *Identity: Community, Culture, Difference*, ed. Jonathan Rutherford (London: Lawrence and Wishart, 1990), 222.

be able to read what is not by and for us. Graffiti's illegibility is intentional. To borrow a term from Eduard Glissant, an antico-lonial thinker from Martinique, graffiti is opaque. According to Glissant, this "opacity" is an intentional form of illegibility that is a mode of resistance against an expectation of transparency and an embrace of the right to not have to be understood on others' terms, a right to be misunderstood. Against the insistence that everything be illuminated, simplified and explained, Glissant suggests that opacity is an adamant response and refusal to be understood on the oppressor's terms.

This Is Modern Art is a play that asks a lot from the audience/reader. In order to empathize with the lead characters—Seven, JC, Dose, and Selena—we must be willing to privilege the life, liberty, and the pursuit of happiness of these young graffiti artists more than we privilege private property. We must empathize with them as criminals. The play's meditation on criminality, statistics about the prison industrial complex and the disproportionate incarceration of young people of color is not ancillary, but essen-tial to the story. The MUL crew evade the police, avoid detection, tactically equip themselves for a quick get-away, and live on the run. But criminality is more than just a fact of life for the graffiti artists in the play. It is a political aesthetic and part of what makes graffiti a fugitive art form. In *The Undercommons: Fugitive Planning and Black Study* (2013), a remarkable text by Fred Moten and Ste-fano Harney, they propose fugitivity as a mode of survival, a lived space and site of ongoing exploration and study, where black culture is both relentlessly and unstoppably emergent and also constantly under threat of disappearing by assimilationist white cultural forces. Fugitivity permeates the black American experi-ence from transatlantic captivity and the starry night journeys of Harriet Tubman, to the intergalactic flight of Sun Ra during his imprisonment in Alabama as a conscientious objector, to the un-derground life of members of the graffiti crew.

The popular slogan from within the movement "Keep Graffiti Illegal" might seem somewhat perplexing and even absurd. Why not advocate for the legality of graffiti and make permission walls, for example, an essential part of every urban landscape? The desire to maintain the street form as an art crime and graffiti's ontology as

an illegal practice can be understood by Frantz Fanon's notion of "reciprocal recognition," which offers insight into the psychology of oppression. In *Black Skin, White Masks*, Fanon provides a brilliant analysis of the rash of criminal behavior in North Africa during France's occupation of Algeria in the 1950s. Fanon explains what might be perceived by some as "savage behavior," but is in fact part of the black man's human need for recognition and as part of his desire for identity, self-worth and dignity. One is human to the extent that one is recognized by the law, and in a society filled with oppression, disenfranchisement, abandonment, and neglect, the full acknowledgement of humanity and integrity as a citizen for some often occurs only when one is subjected to the laws of the state as a criminal.

> I am not merely here-and-now sealed into thingness. I am for somewhere else and for something else. I demand that notice be taken of my negating activity insofar as I pursue something other than life, insofar as I do battle for creation of a human world—that is, a world of reciprocal recognition. He who is reluctant to recognize me opposes me. I am in a savage struggle, I am willing to accept convulsions of death, invincible dissolution, but also the possibility of the impossible.[4]

The play explores the burning desire for recognition as that which motivates the fateful decision of the crew's audacious bombing of a temple of art in downtown Chicago. The dialogues between Seven and Selena (and even their romance that crosses boundaries of race and class, which would have been labeled "miscegenated" and "illegal" a generation earlier) reveal the elemental longing to make one's mark. In a world that would prefer to ignore you, graffiti is one way of insisting *I was here, I exist despite your attempts to kill me and destroy me,* and to insist that a chosen mode of expression be acknowledged, even for the few hours that it might exist, before it is whitewashed by one of the graffiti blasters that constantly roam the city.

4 Franz Fanon, *Black Skin White Masks: The Experiences of a Black Man in a White World*, trans. Charles Lamm Markmann (New York: Grove Press, 1967), 218.

This Is Modern Art does not romanticize criminality and the fugitive status of graffiti. However, art and crime are deeply entangled in the graffiti arts, bound in a relationship like that of the "ship's hold" that Moten and Harney describe—as both a wretched space of enslavement and also the catalyst for radical freedom dreams. SLANG, TRIXSTER, LONE, EMTE, CASPER, RAVEN, and ARK—graffiti artists canonized in the play as those who held on to this truth. The anxiety of being hunted and fear of being caught, and even the possibility of dying for one's art, are the conditions for the collective joy of a creative practice that so exuberantly and provocatively defies the imaginations of those in power in such a magnificent manner.

The outrage that *This Is Modern Art* invoked in mainstream theater reviews and press stood in stark contrast to the enthusiasm of the popular reception, particularly by youth across the city, and its extended sold-out run during the play's world premiere at Steppenwolf Theater.[5] The lacerating complaint issued by critics revealed the compulsive need to condemn graffiti as a form of deviance and an act of vandalism—thereby unintentionally reinforcing all the most poignant and provocative messages within the play. The lack of attention paid to street gang graffiti in the play's narrative was decried as a glaring omission, totally missing the point the play makes about the many specific aesthetic and political histories of graffiti. In the popular media and antigraffiti legislation and campaigns, these differences are always intentionally ignored, and legislators (and critics!) choose to remain ignorant by homogenizing an entire form in their wholesale condemnation. The vitriolic denunciation of the play only added to the feeling by those in the margins and those willing to be schooled that *This is Modern Art* was more than just a play, but part of an urgent revolution.

This Is Modern Art is a warning—for all who care to look—to literally and metaphorically "read the handwriting on the wall." In a story found in the Book of Daniel, text appears by a mysterious hand on a wall at the Babylonian King Belshezaar's feast.

5 See, for example, reviews in the *Chicago Sun Times Tribune* and on WBEZ.

When all of the wise men fail to read or interpret what is written, the King offers power, a gold chain, and robes of purple to anyone who can "read the writing on the wall." This story speaks in a prescient way to what we can learn from *This Is Modern Art*, the history of graffiti and the grappling with this diasporic art form. When Daniel arrives to interpret the text, he is able to read the script: אנמ, אנמ, לקת, וְיסרפו; MENE, MENE, TEKEL, PARSIN. Daniel tells the King that the words are a warning that mean that his days are numbered because he has abused his power and authority, that his leadership has been found wanting, and that his kingdom will now be given to those who deserve it. The graffiti that graces our public spaces, often undecipherable and made by those in the margins, speaks to the imminent demise of power, of exclusionary cultural institutions that abuse their authority and fail to represent the people and to recognize the capacious, colorful and diverse world of all that is beautiful, true and just.

Lisa Yun Lee

Preface

On February 21, 2010, the east wall of the Art Institute of Chicago's New Modern Wing was defaced with a fifty-foot graffiti piece painted by a team of writers in about 20 minutes.

On March 10, a graffiti writer named SOLE was painting a mural on the wall of an abandoned factory. When police showed up and gave chase, he flung himself into the Chicago River and drowned.

> *We began shocking common sense, public opinion, education, institutions, museums, good taste, in short the whole prevailing order.*
> —THE DADA MANIFESTO, 1918

> *Dada philosophy is the sickest, most paralyzing and most destructive thing that has ever originated from the brain of man.*
> —AMERICAN ART NEWS, 1918

So somebody went and done drew a mustache on the Mona Lisa. Which is to say, somebody took aerosol to staple, mocked how we consume our culture. I imagine them smiling when they did it. Because it's all just make believe, isn't it? Private space // public space. Unreal lines. Agreed upon modes of presentation.

The image has long since been blasted away. It's business as usual at The Art Institute of Chicago: Euro centrism and expensive cheese shoved down throats that reflux the same tired conversations.

Law-abiding artists, civilized, pontificate: *What does it mean?* Building upon the legend, filling up temporary space. Is it: *Vandalism? Street Art? Graffiti?* Whatever *it* is has proven gatekeepers ignorant by infiltrating the institutional art machine.

Terms like "hip-hop" woo corporate philanthropists, "urban" a call to arms for chic intelligentsia the world over. It's widely emulated. Detroit, Michigan. Iowa City, Iowa. Those same bubble letters, jutting angles. Santa Fe, New Mexico. Cheyenne, Wyoming. Those same stencils and polemic sentiment. Nairobi, Kenya. Amman, Jordan.

I am a rapper introduced to hip-hop culture through commodity. My early engagements with rap music were mediated by radio, cable television, the sterilized confines of the mall's record chain. I experienced the renegade of rap after it had been scrubbed, bleeped. I felt the furious wild style from a safe distance, witnessed the body's pops and spins behind glass. I copied.

I, like many artists, have benefited from those who risked their bodies crossing invented boundaries. Those who risk their bodies to steal, hustle, con, bend the bars to prove another paradigm is possible. We pick and tear, wear their skin, swallow their tongues to better define ourselves. We press their remains on t-shirts long after they've been crushed by narrow, elitist agendas.

It's all make believe. Institutes are machinations like constructs of race, wealth, success. A shared hallucination. All that is real and undeniable is this animal need to survive, the human desire to exist after the flesh dissolves.

There will always be those who loiter outside our hallowed halls, those who haven't a taste for stinky cheese. And if they are not greeted, they will introduce themselves.

It will not be creased nor presentable. It will test the patience of the liberal and learned.

We will have to stop for a moment, mute ourselves, and think about what it really means.

Idris Goodwin[1]

1 This essay originally appeared in *These Are the Breaks*, published in 2011 by Write Bloody Press.

Introduction

when a crew of graffiti writers bombed the outside of the new Modern Wing of the art institute in Chicago, i thought it was the most exciting event in hip-hop visual memory, comparable to when Sane & Smith, NYC brothers & bombers painted SMITH, a working class regular everyday person's name, on one of the giant pillars of the brooklyn bridge & new york city went mad & hunted the culprits for marking on a landmark and reclaiming a monument for the people.

· in February of 2010, when the mural on the east side of the Modern Wing went live, i caught wind on the internets and knew several things: the crew of writers who painted a 44-foot mural in 14 minutes on the new museum wing in a snowstorm must have been planning that for a minute and because they wrote "Modern Art" one of the few pieces of intentionally legible lettering, "a clean ass handlstyle," they left right above the student entrance sign, i felt they were engaging in not only the typical contestations of public space reclamation graffiti partakes in whenever a kid scrawls their name on a wall next to an advertisement for

coke or newport or sprays crew letters near a billboard or city sign, but this was a challenge to the museum, the curators, the white box, the preciousness of the institution, and the history of a cannon that practices and maintains a white supremacist & patriarchal lens.

by calling the mural, the collection of four burners, modern art, the graffiti writers were also prying open the western cannon, were also calling out the cost of the museum, a museum on public land, the lack of painters of color inside, the lack of Chicago artists in the collection, were also questioning who art is for & by & why . . .

at least these are things i was thinking & starting to teach in my class at the art institute when i was there teaching with Dr. Lisa Lee about hip-hop aesthetics. we immediately began to use this incident as a test case for the impact and power of the genre.

i mentioned to one of my colleagues, an incredible poet, teaching artist & hip-hop head, Britteney Black Rose Kapri, i was using this incident/happening/mural at SAIC, and she said she knew them dudes. and i was geeked & on my Studs Terkel wanted to talk with them, which was a big ask cuz they were underground, similar to how my mentors Bill Ayers & Bernardine Dorn went underground during their weathermen days.

but after some time and coded communications, Britteney made the intros & i told the actual people who became Seven, JC & Selena that my homie, Idris Goodwin & i wanted to turn their stories into a play. and they were down and incredibly generous and at the time of this publication still underground for fear of retribution, fines in the millions of dollars and felony jail times cuz the way graffiti is criminalized in this city, which is to say the way the prison industrial complex wreaks havoc in the lives of working people and on bodies of color.

the interview became the basis of the play Idris pitched to Steppenwolf Theater, who miraculously said yes and the Kennedy Center gave us some space and a room and week to work and workshop and we took the transcripts of the interviews and wrote a play.

and the play premiered on Feb 25, 2015, almost five years to the day of the event depicted on stage. the cast was multiracial

like the audience and the theater was packed and i snuck the real writers who the play is based on into opening night, unbeknownst to the theater, and we felt really good.

and in the graffiti and Chicago hip-hop community the word spread and older heads and writers and younger heads and writers and high school students from all over the city were talking and giving us props and shade and the conversation was already mad exciting and then the reviews in the two big Chicago newspapers came out, both done by critics who are older and white and not versed in the culture and they talked tall shit about the play which is cool, but the not so coded language they were using was mad racist and elitist and ancient.

and the people clapped back. the internets responded to the papers and critics and told them about themselves and the conversation raged on social media and what happened when the piece went live five years ago was happening again on the stage and in real time, and Idris and i felt like NWA, the world's most dangerous playwrights.

This Is Modern Art is a story about liberation, about vision and dreams and doing the impossible regardless of the constraints. it's about countering dominant narratives, about breaking open and doing away with the western cannon, about young people in Chicago resisting what the city thinks of them, of creating despite a highly criminalized art form, of creating in a crew, a community, finding a makeshift family, believing in your self and your people against the world/city/country/system that tells you your voice/art/action/life is not as important as the wealthy/white/established mugs in the museum or city hall.

this is a play about freedom and resistance and the struggle to counter the wack monolith. i'm curious what you think.

kevin coval
may 2016

CHARACTERS

THE WRITERS (4)

Seven: African American male, early 20s
Jose Clemente / JC: Mexican American male, early 20s
Dose: Puerto Rican American male, early 20s
Selena: White female, early 20s

THE OTHERS (2-4)

White male ensemble player, late 30s to late 40s
Marco / Police officer / Selena's dad / Student /
News anchor / Responders

Black female ensemble player, late 20s to mid 30s
Rhonda / News anchor / Student / Responders /
Police rep / PR

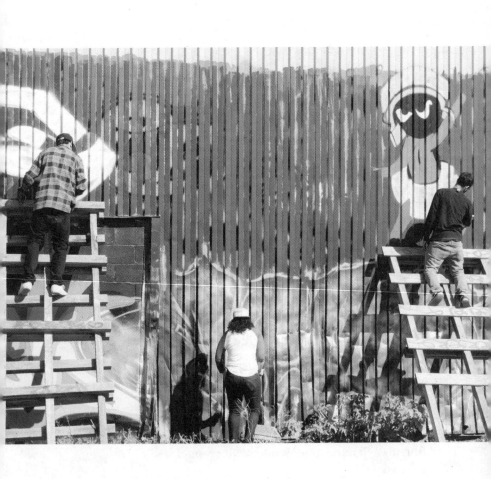

Lights up on Seven, speaking to the audience.

SEVEN

The right piece of graffiti will change somebody's life. I know it. The sight of it, knowing that another human being could go against the will of the rest of the world.

This is not a confession.

Beat

——

Transition

Selena is in her car, wearing an earpiece. We hear the "click clack—psssttt" of the aerosol cans. Fade up on Seven, JC and Dose inside the Damen silos—an abandoned factory, working on walls. Littered across the ground are cans, bottles, wood, glass and debris. The walls have color everywhere.

SEVEN

(in an ear piece)

How's it lookin out there, Selena?

SELENA

You guys are good, Sev. It's a ghost town.

SEVEN

You good tho, love?

DOSE

(*mocking voice, makes a kissy noise*)

You good tho, love?

Sev, cakin' too hard. What we in, a hostess factory? You hear this dude, Jase?

Turns to JC who is deep in concentration. He ignores Dose.

Jase?

SEVEN

Leave 'em be. He zonin', anyway. So yo, Dose, I peeped some of your little spots off Fulton. And out west on Lake Street. You been gettin' up heavy.

DOSE

Ya boy is everywhere, my dude.

SEVEN

Word up. I ran with FACT the other day. Ripped a whole run of warehouses.

DOSE

He nice with it. Bubble letters. Craaazy.

SEVEN

True . . .

DOSE

But yo, he told me ENOCH is only doing permission walls now.

SEVEN

Word?

DOSE

Yeah, he's on his second strike so he gotta take it easy.

SEVEN

I respect that.

DOSE

(with emphasis)

Yeah, but permission walls tho . . . ?

SEVEN

What's your beef with permission walls?

Dose makes a sound: Pffft!

SEVEN

What? If somebody offered you a stack and some paint to do a wall—legally—you'd say pffft!?

DOSE

I'm a purist, man.

SEVEN

Whatever dude. Can't knock a cat for wanting to evolve. I mean, don't you ever think about spreading out, moving in some different lanes?

DOSE

Nah. What? You trying to retire or somethin', Sev?

SEVEN

Nah, course not. Never that.

More painting.

SEVEN

Sometimes I just wanna get outta this little like ghetto we in, you know? Like it's cool what we do, don't get it twisted, I mean we *every*where, all the writers know LOH business.

DOSE

True.

SEVEN

We red line kings. Got styles and styles.

DOSE

For days, my g. I'm a style master. (*Dose counts off on his fingers*) Wild, bubble, throw-ups, pieces. You already know!

SEVEN

I do, man. I do. It's masterpiece theater up in here. But who's gonna see it?

Dose thinks a moment.

DOSE

Y'know—other writers. And homeless cats. And cops.

SEVEN

Uh I don't think cops appreciate the styles.

Dose laughs.

SEVEN

I just want more people to appreciate all the style.

DOSE

What people?

SEVEN

I feel like we stuck in this little ghetto they built for us, for us writers, you know. Sometimes I wanna bus out. Do something BIGGER.

DOSE

Oooohhh something bigger.

SEVEN

Right.

DOSE

You wanna go to war!

SEVEN

Uh nah.

DOSE

You got beef and wanna take out some toy-ass crew? I'm with that. I've been wanting to crack someone in the face for a minute, yo. Who you got beef with?

SEVEN

Nah D—D—

DOSE

Those weak-ass HI-C boys? What's a HI-C anyway? What they some capri sun juice box drinkin', little kid-type wanna-bes?

SEVEN

Nah man. It's not how I—

DOSE

Wait, wait, wait. They talk to Selena all crazy? Yo, let's take out these toys.

SEVEN

Nah, D, chill b. Nah (*laughing*). Not like that . . . at all. I'm sayin' I feel like what we do is pushed to the side, you know. Like, folks don't know how nice we are with it cuz these pieces get buffed so quick most of the city don't ever really get to see our art.

DOSE

True that, yo. I pieced the other night on 290, near that old refrigerator spot off Cicero. You could see it from the highway. In the morning I had my OG drive me past the shit on her way to work and it was already gone, yo!! Punk ass graffiti blasters took it down! And the piece was beautiful Sev, I had some of those pineapples and raspberries I had *just* racked! AHH!! It was crazy my dude, I couldn't even catch a flick of it though.

SEVEN

That's what I mean, D. I wanna create something that lasts. I'm not talking graffiti writer fame, you know, I mean . . . wait—hold up—(*into ear piece*) what's up, Selena?

SELENA

There's an unmarked Crown Victoria coming this way, I can't tell if it's "five-oh" or . . . wait, it's just some Puerto Rican cats. Sorry Sev, we all good.

SEVEN

Cool.
(*back to Dose*) Yeah man, I was saying . . .

 JC
You were saying you want to be a legend.

 SEVEN
Yeah man, basically.

 JC
Legends stand on their work. When you discipline yourself to
become a great artist, legendary status will be left to those who
write history.

 SEVEN
What if the people who write history are some narrow-minded
busters who stay getting late passes on what's fresh.

 JC
The hope is to be great enough, to be disciplined enough and
put in so much work that my legacy will be undeniable and his-
tory will write itself.

 SEVEN
I feel you Jase, and you my man and all, but I'm saying fuck those
who write history.

 DOSE
For real man, fuck those dudes . . .
Both JC and Seven side-eye Dose.

 DOSE
What?

 SEVEN
I'm sayin' I wanna do something that will have an impact *now,*
not years from now, you know? Cuz *now* is where we live and *now*
is all messed up and *now* is the only time we got, and *you* know
that better than anyone, Jase.

 DOSE
Man, I love when y'all fight.

JC

So you got a plan for *now* then, Seven, or you just talkin'?

Waitin' on paint to dry?

Seven ponders a moment but Selena speaks before he can respond.

SELENA

(Through the earpiece)

Guys! We gotta go!

They scatter.

—

Transition to THE PARTY

Seven's living room. Music plays, red cups with beer, people standing around, talking, laughing. A netless ping-pong table is in the center of the room. A conversation between Marco, Rhonda, and Seven.

RHONDA

They had *everything*. Wall to wall. I mean, we're talking about Picasso's *Mother and Child, Time Transfixed, Bathers by a River.*

MARCO

It was wall to wall, man.

SEVEN

Yeah, I know all those paintings. I'm sure they had Rothko.

MARCO

Rothko. Pollock.

RHONDA

De Kooning's *Excavation,* Kandinsky.

SEVEN

Yeah. Yeah.

RHONDA

It's like, finally! Something refreshing. I been going to the Art Institute my whole life. I mean we all went to the Art Institute growing up. It never changed *that* much.

MARCO

But this new Modern Wing—it's beautiful, Seven. They got Renzo Piano from Italy.

RHONDA

Yeah, he designed the High Museum in Atlanta, the Astrup in Norway, this airport in Osaka.

MARCO

Dude, it costs 300 million dollars and it looks like they spent every penny of it. Glass, steel, limestone—you would love it.

RHONDA

Gorgeous building. It has this like—what'd they call it?

MARCO

Flying carpet—

RHONDA

Yeah. Flying carpet roofline.

SEVEN

Yeah, I seen that.

RHONDA

So you been there?

SEVEN

Just seen the outside. I work down the street. At a restaurant.

MARCO

You *still* workin' there?

SEVEN

Shut up, man. But yeah, I seen it from the outside.

RHONDA

All the graduate art students got tickets to the opening.

MARCO

Perks of dating an art student, right?

RHONDA

Everybody in the art world was there tonight.

SEVEN

(with a loaded tone)

Everybody? Like for real *everybody*?

MARCO

You know she means, not everybody.

SEVEN

Nah, she said everybody.

RHONDA

Wait, what?

MARCO

(Slightly mocking)

Seven wants to know if there were graffiti writers there.

Rhonda chuckles.

RHONDA

I doubt it.

More chuckles. Seven is not amused.

SEVEN

What's so funny?

RHONDA

I thought you were joking?

SEVEN

Why it so hilarious that graffiti writers would be at the Modern Wing?

RHONDA

Oh. Okay. I see.

We're talking about two different—trajectories, aren't we? I mean, isn't that the point of what you do? That you're *everywhere* BUT the safe white-washed confines of the museum?

SEVEN

We only paint *everywhere else*, because they won't let us paint inside.

MARCO

Wait, galleries have shown graffiti art for decades now.

SEVEN

Yeah, they might do they little street art week or whatever but they'll never integrate us into the regular flow. You'll never see a cubist piece next to a regionalist piece next to a wild style on canvas.

RHONDA

But is graffiti on canvas even graffiti? They been posing that question since the New York art world in the eighties starting treating it like a fad. Like breakdancing or the slinky?

MARCO

Can't it be both? Like I know a lot of graffiti guys who work in the studio and on the street.

RHONDA

Isn't that when it stops being graffiti? When it stops being an act of rebellion? Graffiti's not about permanence, right? There's a

performative nature to what you do. A daredevil, agit-prop aspect that contextualizes every piece you create. You're talking about art that barely lasts 24 hours. It's not about creating an archived body of work. How can it be? It's art made by the anonymous.

———

Transition in scene—Seven turns to us. Chicago graf pieces run on screen.

SEVEN

We do have a canon. She just don't know it. Hell, y'all probably don't either. The history of graffiti art is deep. Chicago alone goes back to '79. But my man JC can speak on that.

Seven pulls JC from his conversation into the moment.

JC

Okay. Nick Salsa moved from New York to Chicago and started the CTA crew. Writers like SLANG and TRIXSTER were pioneers. '83, PLEE FRESH linked up with STANE and KAOS to form TCP—The Crowd Pleasers.

85, the CTA crew is the first to bomb the Ravenswood Yard. They were the first to *king the line.*

SEVEN

(to the audience)

Which means they hit every train line.

JC sighs.

SEVEN

What? Some of them might not know what that means.

 JC

(shaking his head, continuing)

Down in Pilsen. You had these real well-known fine artists, masters of the Mexican mural style. They would invite guys like ZORE, FESS, Nick Salsa, CAUTION down to collaborate. Hooked them up with paint, spots, the whole nine.

 SEVEN

That was back in the early '80s!

 JC

You had writers like DEPTE (God bless the dead) LONE, EMTE, CASPER, RAVEN, ARK.

 SEVEN

Oh shit. ARK is a monster—point blank.

 JC

He *only* painted CTA trains. Most guys start out doing low-risk stuff—throwin' up tags here and there. But ARK was a writer of ambition.

 SEVEN

ARK studied under TEMPER THE EMPOROR, who along with Ages, was *one* of the first to go all city.

 JC

(to audience)

Which means he pieced on the northside, the southside, the eastside, and westside.

Seven shoots JC a look.

 JC

(a satisfied grin)

What? Some of them might not know what that means.

———

Transition back to scene. Rhonda is in mid-rebuttal.

RHONDA

. . . It's not like I'm saying there is no history. But your history is not being designed and archived in such a way that even has contemporary art spaces in mind. Look, what you do is crime. That's just real. I'm not some fist-shaking square here. I get it. You're challenging the right to public space. That's why people see it and they don't say "oh isn't that nice." They say, "how'd they get away with that?"

But for every piece you create, no matter how vivid and bold, on the other side there is a victim.

MARCO

Yeah, you know, my uncle is a mechanic. Every time somebody pieces on his shop, he has to pay to remove it or remove it himself or he gets fined.

SEVEN

But that's not our fault. What if he wants to keep it up? If we had the time to properly piece a mural it would just make his shop stand out. Add the name of his shop and his phone number up there. It would let the people in the neighborhood know where to get they car fixed.

RHONDA

I think you're missing my point.

The definition of graffiti is illegal practice. Therefore you exclude yourself from the world of fine art. Which is not a bad thing. One's not better than the other. But don't be surprised when they don't invite graffiti writers to the VIP gala at the Modern Wing of the Art Institute. I mean, where would they send an invitation?

MARCO

They'd have to go over one of his pieces.

Marco and Rhonda share a chuckle.

SEVEN

Y'all funny.

So y'all don't think we'll ever be *inside* the museum?

RHONDA

No. I don't. But is that even where you wanna be?

—

Transition

A spot light on JC. JC speaks to audience.

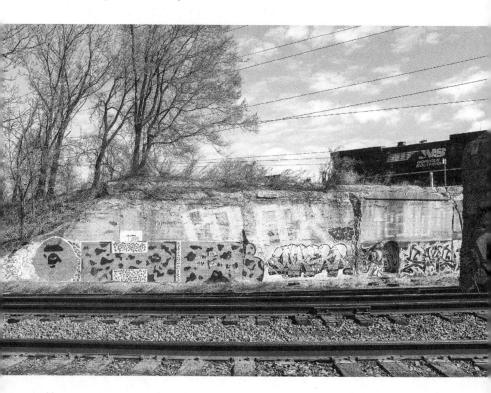

JC

First time I went to the Art Institute was in the seventh grade. I had this art teacher, Ms. Simkins. She'd take us on field trips all the time. One spring she took us to the Southside, to the DuSable Museum. We met the woman who started it, Margaret Burroughs. This 80-year-old black woman in a bright purple African dress and a pair of Jordans. Like *for real*. I mean, I never knew museums could be started by old black women . . . wearing Jordans.

And she said she spent time as a student in Mexico learning from The Mexican Muralists. Which I thought sounded like a graffiti crew. And I guess in a way they were. She worked with Diego Rivera and José Clemente Orozco and David Alfaro Siqueiros. And I never heard of them. But I remembered Jose Clemente because of the ball player, Roberto Clemente. So when I got to school, Ms. Simkins helped me look up Jose Clemente the painter and we found these murals he did on a college campus. These murals were cold! They told the story of his people, the Latino people . . . my people. I wanted to tell the stories of my people, too.

So I started to write, Jose, JC, Jase, for Jose Clemente Orozco. JC. Jesus Cristo. The lord and savior.

—

Transition

Morning after the party. Their apartment is kind of a mess. We see Seven, Dose and Selena—nobody is cleaning up except for JC who separates aluminum from plastic from glass. The LOH is chillin'. Seven and Dose in notebooks. Selena on the computer.

SEVEN

(to JC, showing him his notebook)

Yo. What shade would you use up top here, man?

JC

(peering at the book)

Blue.

SEVEN

We talkin' baby blue? Sky?

JC

Darker.

SEVEN

Okay.

JC

I'm thinking of a color reminiscent to when the sun drops just west and all you see is an almost black-blue, with a purplish tint.

SEVEN

Yeah, that midnight blue. Word up. That'll make that shit pop. That shadow blue.

DOSE

I just racked like five of those. And Sev, you can have one . . . if I can make out with your sister.

SEVEN

D, you know she won't mess with [*insert racial group of actor playing Dose*].

SELENA

Y'all are gross.

Some laughter among the crew. Seven gets up.

SEVEN

(groans)

Gotta go to work.

Seven starts to gather what he needs.

SEVEN

What you doin' over there, love?

SELENA

Looking at these new R2D2 flicks.

DOSE

What site you on?

SELENA

Art Crimes. He's got a whole car on here!

Seven goes over to see.

SEVEN

Damn!

SELENA

R2D2 has no small ideas.

JC

No doubt. Letters. Style. Very ambitious.

SEVEN

I'm glad we came up with him, you know. It's like, you rise with your circle. You feel me? We all learn from each other like ... the surrealists or abstract expressionists, all learned from the folks in their crew and that's what we do now.

SELENA

They should teach art history that way.

SEVEN

Right! If you saw how it bleeds together, it's not boring. You know, these movements are a progression of style. They evolve into each other.

SELENA

Didn't y'all do art school?

SEVEN

Kinda.

JC

I couldn't afford a Mac, so I had to drop out.

SEVEN

I couldn't afford tuition. So I had to drop out.

Some laughter.

DOSE

Man, I just learned off the internet.

SEVEN

Yup, yup. I did a semester of college and realized they was charging me dumb loot to learn a buncha names I taught myself online for next to nothing.

JC

Exactly.

SEVEN

I been up on the internet since it was dial up. Back when you'd sign on and it'd be like—CH.CH.SHHHHHHHHHHHH (*sounds*). Altavista searches. Like this is before there was a Google. Altavista was the shit.

DOSE

Netscape was my shit.

JC

You could visit every museum in the world. Meet Michelangelo, Rembrandt, Caravaggio.

SEVEN

Caravaggio is one of my favorites.

DOSE

Meh!

SEVEN

What!?

SELENA

Who is Caravaggio?

JC

He used some of the first controlled lighting.

SELENA

You actually like these old guys?

DOSE

Nah, not me. I don't sweat the dead man.

SEVEN

You sayin' you don't get down with MC Escher?

DOSE

He an old school rapper?

No one laughs.

DOSE

Y'all are lame.

Seven looks for his keys.

JC

Extreme intricacy. Escher. With all the stairs. Everybody loves that drawing to this day.

SEVEN

Escher was a mystic, yo.

DOSE

Okay, maybe I mess with Dali. That dude was dope. He literally was able to slam his head against the canvas and smear his brain out. That's what I'm tryna be on.

JC

His smooth transitions in contrast and juxtaposition of color and explorations with form. Your mind just had to submit to it even if your brain can't agree. It is madness.

SELENA

You guys are talking like he was . . . Lil' Wayne.

JC

Lil' Wayne is not timeless. He's a ubiquitous blob of . . . capitalism.

Seven stops in his tracks.

SEVEN

Man, I don't know what you talkin' 'bout. Wanye is a genius! He's in love with the mircoscopic aspects of language and syllable like some painters are with each brush stroke.

SELENA

Seriously, this is like, *crash art school.*

SEVEN

Right. Maybe we should invite that lady from last night back over here to learn somethin'!

SELENA

Who?

SEVEN

That lady talkin' greasy about how we won't be in the museum.

DOSE

Later for her, man.

SEVEN

That's that shit I don't like tho. We know about all they history. All they heroes but—when it come to us. It's like—oh we're just—forgettable—arts and crafts—like I was sayin' before—boxed into a ghetto.

DOSE

Preach!

SEVEN

But we up on all sorts of canons—western, eastern—hip hop, graffiti—we got all that! We walkin' art schools. Each of us.

And we ain't just making pretty drawings. They're more than that.

Like, if you're not going to mean anything, then it's just painting the same-ole-same-ole to match your couch. To hang in the living room in your condo.

DOSE

Some Ikea shit.

SELENA

Yeah, right. Like, if you're going to take a risk, might as well be for something that matters.

SEVEN

(playfully mushy)

Yeah, that's right, y'all. She's with me.

They share a playful embrace. JC goes back to his cleaning, and Dose feigns disgust.

SELENA

(Speaking to us)

I met Seven at a loft party off Randolph one of my girls dragged me to. There are all these scenes the city keeps hidden. The mix

of people was incredible. I saw this guy holding court talking all passionately and he looked at me. And kept talking, but he stayed looking at me. Later on, he introduced himself as Seven. We talked for what seemed like a few but when I looked at the clock it was just after 3.

(*nonchalant*) He was cool. So we went on what I guess you could say was a second date.

—

Transition

A year or so earlier. The second date between Seven and Selena. Seven is pulling up the lower corner of a fence. He motions for her to crawl through. She hesitates.

SEVEN

Trust me. You're gonna love it.

Selena dips through, Seven follows. They step cautiously.

SEVEN

Okay, close your eyes.

SELENA

I'm not an idiot, dude. I'm not closing my eyes.

SEVEN

Nah, it's not like that. Come on.

Seven steps behind Selena and covers her eyes.

OK. Just a few more steps.

Closely and slowly they move toward the front of the stage. Seven lifts his hands and turns Selena's shoulders, their backs now toward the audience. A crew piece, LOH, is revealed flying high in the night sky at the top of a warehouse or water tower.

SEVEN

Right over there. Check it.

SELENA

She looks where Seven points.
Whoa.

SEVEN

Right?

SELENA

How the hell do they get all the way up there?

SEVEN

I could show you.

SELENA

Ah, that's ok. I'm staying right here.

SEVEN

All right, that's cool . . . but walk with me though?

Seven reaches back for Selena's hand. She thinks about it but decides to take it. They walk around a corner to see a run of pieces on the wall. They take in a few pieces in silence. Seven looking at Selena and at the wall.

SELENA

My God . . . This is like a real art gallery.

SEVEN

Right.

SELENA

This is crazy. It's so beautiful.

SEVEN

It is. And so are you.

There is a pause but recognition of what is said. Selena is quick to move the moment along.

SELENA

But I don't really know what a lot of it says.

SEVEN

You can't read that?

SELENA

Some letters . . . I think that's an O, there, maybe an E.

SEVEN

See over there you got a NOTEEF piece right? Then in the corner of his piece, you see that KWT, that's his crew. The writer reps for the I and for the WE. For me and the whole damn team.

SELENA

Can I ask kind of a stupid question?

SEVEN

I promise you I will not think it's stupid.

SELENA

(a bit flustered / flirtatious)

Ok, cool . . . you're sweet . . . ah, ok. You said "piece," what's the difference between a piece and like a tag?

SEVEN

Oh, that's a DOPE question . . . see you got tags, throw-ups and pieces. A tag is something quick with like a paint marker. One color, one line, a continuous line. Something you done a million times. You tag on mailboxes or doorways or stop signs.

Seven whips out a marker.

SEVEN

Like this.

He demonstrates.

SELENA

Wait, you can just do that?

SEVEN

(with a smirk)

If I don't get caught.

Caps the marker and continues on.

SEVEN

Now a "throw-up" is a more elaborate tag, usually done in a few colors. Maybe a black or white outline with something bright to fill in. You see 'em around more, on the grates of stores when they close up for the night or alleys or the outsides of buildings just off main streets or rooftops so folks on the train could see.

SELENA

I love those.

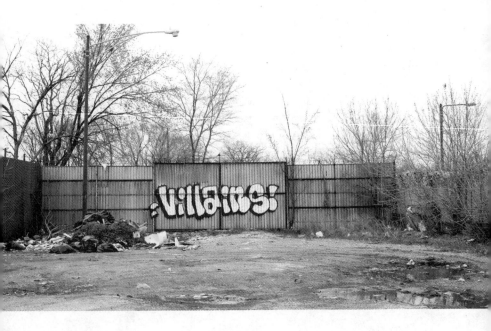

SEVEN

And a piece, a piece is short for masterpiece. And don't get me wrong, I love hand styles and dope bubble letters, but pieces to me are the most beautiful. Large, detailed, intricate, colorful and complicated, they can be illegible to most, unless you're another writer, we call it wild-style.

Selena spots another one.

SELENA

What about that one?

SEVEN

Which one?

She points up high.

SELENA

It just seems—different. The colors are brighter, there is more happening in the background. I can't read what it says at all, but I know the letters curve different . . .

SEVEN

That's me.

SELENA

Really?

SEVEN

Yeah.

SELENA

How did you get all the way up there?

SEVEN

It's only our second date, I don't wanna incriminate myself.

SELENA

You got me breaking and entering here, Seven. You're a gateway drug . . . to a life of crime.

—

A transition. Selena turns to the audience.

SELENA

In the neighborhood where I grew up there were a lot of Latin Kings, so you would just see a lot King graffiti all over the place. The gangs mark territory or mourn their dead or send messages to rivals.

But that's not the same as what these guys do. Over the course of our third, fourth, fifth, sixth dates—I learned about all the hidden spots: the bridge at Ashland and Webster near the water filtration plant, in the meat packing and industrial district between Halsted and Sacramento and Grand and Fulton, the freights at North and Elston, the Damen silos, Brach's candy factory, all up and down Lake street.

I learned the names of writers BANDIT, NYKE, ASEND, AMUSE, JACK and JUICY, ELOTES, PAGE, KANE, REBEL THE RED LINE G-D, NEKST-(Rest In Power)

I learned crew names—CMK, KWT, CSU Can't Stop Us, DC5, Dirty 30, ABC Artistic Bombing

Crew, TMK, and Seven's crew, LOH. Look Over Here.

I thought graffiti was just people going out spray-painting their names on things and whatever, but there's this whole society.

I wanted to be a part of it. I can't paint or draw. But I do have a car.

On our 10th date I started to drive them. It was more adventurous than I'd ever been.

I keep them updated through the earpiece. Tell them who is coming and who to look out for.

I'm not just some graffiti groupie. I'm their lookout. They need me.

—

Transition back to the apartment. Selena is reading, Dose is taking a nap, JC is in a black book. Seven busts into the apartment, mad-excited, carrying his backpack and in it a rolled piece of paper.

SEVEN

Ay yo! What it do LOH crew?

(to Selena)

How you feelin', love? Book good? You have a good afternoon?

SELENA

Yeah, I'm good. You're . . .

Seven cuts her off in excitement to JC.

SEVEN

What's good, my dude?

Looks around JC's shoulder into his black book.

Jase in the lab cookin' up another masterpiece!

JC

Are you rolling, Sev?

SELENA

Yeah, why you in such a good mood?

SEVEN

I'm *great* y'all . . . Ayo Dose wake your punk ass up!

Dose is comatose. Seven knocks the hat off Dose's face.

DOSE

Oh, come on!

SEVEN

When we hit those condos on in the Gold Coast, THAT was big.
When we bomb trains, THAT is big. I got a plan for something
even BIGGER.

SELENA

Slow down.

DOSE

This dude is tweakin'.

SEVEN

Nah, I ain't tweakin', I'm inspired, yo! On my way to work, almost
everyday, I walk by the Art Institute. And I look at that Modern
Wing.

Every day I see that bridge that hangs over Monroe like a staircase
to heaven for the rich. Every day I see it. Every day I see tourists
go in and northside schools groups and hip young trust fund art
students in their five hundred-thousand-dollar eye glasses and
I'm like: "Who is this art for?" and even more "Who is this art by?"
You feel me?

DOSE

Sev I was in REM sleep, man. Dreamin' I was racking cans with
your sister.

SEVEN

Man, shut up.

SELENA

Seven, what's your point?

SEVEN

So I'm on break, right. It's like just after 2, and you know I stay
prepared.

Legacy our history, right JC? You taught me that. I've been carryin'
that chrome Montana marker of late and was goin' to the lake cuz

they stressin' me at the gig plus it's mad nice out, it's misty, so not a lot of folks walkin' around, but nice.

I see The Art Institute's little sculpture garden, right off Michigan. They left one of those motorized air ladders out and it's running to the rooftoop. You know, it's one of those joints Mr. Telephone Man use. It look like Inspector Gadget's arm or some shit. But it's just out so I'm like *daayyyyummmm, I caught 'em slippin'*.

I make my way slow but swift and I jump on that bad boy. Make my way damn near to the top and bust a tag, right on the outside of the museum.

 DOSE
Yeah, that's dope.

 JC
Yeah.

 SELENA
Nice.

 SEVEN
My tag only ran for like 20 minutes though. I saw 'em take it down comin' back from break. But ... don't y'all see?

They don't see.

 SEVEN
It took 'em a whole 20 minutes to take down my little tag, imagine something even bigger.

 JC
Like a piece?

 SEVEN
Yes.

 JC
You wanna bomb the Modern Wing?

 SEVEN
Not just me, all of us.

 DOSE
Say what?

 SELENA
Excuse me?

 DOSE
Can't be done.

 JC
It *can* be done.

 SEVEN
Thank you!

 JC
Just not without getting caught.

 SEVEN
Yo, before y'all start with all that nay sayin'—just peep.

Seven spreads his hand drawn version of the blueprint/layout of the Modern Wing on the ping-pong table.

 SEVEN
You see right here on the back side, off Monroe, there is this high wall around five to seven meters, then there is this little buffer wall in front. It's kinda like they built the building to be painted.

 JC
How big is the wall?

SEVEN

Like 40, maybe 50 feet.

They study it.

DOSE

How much time we got between patrols?

SEVEN

About 15 minutes between cars and the security inside walks the building every hour. So we'd have 14 at max.

SELENA

Fifty feet in 14 minutes. Guys, I know we're good but—this is gonna take some serious planning.

SEVEN

Of course. Heavy planning. It's just some next level shit. Like when Sane and Smith hit the Brooklyn bridge.

DOSE

Now that was ill!

JC

New York City sued them for 3 million dollars.

In unison: "daaamn."

SELENA

We'd catch a fine like that for something like this, not to mention major jail time.

SEVEN

Sure . . . if we get caught.

SELENA

ETHER and UTAH—between them they got six months in Rikers, $20,000 in fines, six years probation, five-year ban on going to Boston.

DOSE

It's Boston tho—they were doin' them a favor.

They study the drawing.

SELENA

Okay—hypothetically—I'm not saying I'm in—But if we were to do it—I guess I could park—(*scans the image*) Here. Monroe and Columbus. I can see y'all, the building, north to the parking garage all the way south and any cop cars coming west off of Lake Shore.

JC

We have to account for surveillance cameras.

SEVEN

We'll wear masks and hats and we'll do it at night.

JC

Still pretty risky.

DOSE

I got a guy I know. We went to grammar school together. He works for one of them surveillance companies. Owes me a favor.

SEVEN

Oh word?

DOSE

A lot of these big downtown buildings they use external systems so that there's no way to cut any line or rip any wires out. I'll holler at him and see if he can tell us what's up with their cameras.

SEVEN

Dope. So you down?

DOSE

Like James Brown my G.

Gives Seven some dap.

SEVEN

How 'bout you, love?

SELENA

(sighs)

Gonna take a lot of planning.

JC

I have no fear or doubt that we can piece this wall in 14 minutes.

SEVEN

Right! Thank you.

JC

But—you say you wanna do something BIG, something that matters—something for the people.

SEVEN

Hell, yeah.

JC

You sure this ain't just some personal vendetta against somebody talkin' trash at a house party?

SEVEN

Of course it is! But not *just her*—I mean, I'm not even mad at her.

DOSE

You *was* a little salty, Sev.

SEVEN

At first. But I realized it's not her or—like, it's not her fault. Her whole perspective has been shaped by definitions: high art, fine art, street art, museum art—whatever whatever. Institutions are built on them. They need these to justify their existence. Museums, symphony halls, theaters, operas—run by people who ain't artists. People in big offices making decisions that affect who gets to represent, what art we get to see, who gets what paint, who gets

what space to paint in, what art we make, how much we make —
nah, man. I'm tired of it.

> JC

This isn't purely about your ego.

> DOSE

Of course it's some ego shit—every crew within 10,000 miles is
gonna wish they thoughta this.

> SEVEN

Nah, Dose. For me it ain't even about that. It's about that 2 maybe
3 hours that it flies. Before they buff our shit. Some people'll be
able to see it, some'll take pictures, tweet about, talk about it at
work, talk about it for weeks, months—we might even make the
news. But it ain't about that either. This is a chance to show peo-
ple that there are real artists in this city. Right now. Living and
grinding everyday to make their art. And they can't wait until
we're dead and gone to give us our recognition. We gotta let 'em
know. We're here. Right now.

You feel me, Jase?

Contemplation in silence. JC gets up and walks out.

> SELENA

Uh—Where's he goin'?

> DOSE

It's all good. He just goin to sit on the mountain top.

———

Transition

JC onstage, walking and talking to the audience.

> JC

I clear my mind in *heaven spots.* I love this city. *This* city. The ur-
ban wild, the cracks in concrete where life rises. There are berries

you can pick, grapes you can eat. I've seen snakes, owls, hawks, rabbits, rats. The homeless make camp here, under overpasses, along train lines, in the spaces you don't look. I walk for hours on trails the indigenous tracked. I walk train tracks that used to move animals in boxcars around the country. They are empty. I see the prairie. The flat land we've made mountains on. I climb water towers and billboards and stories of brick to find places to write, yes, we call them *heaven spots*, tough to get at and perhaps you can die trying. And I did come here for fame, initially, the desire to have the city see my name flying in spaces only machines could reach, super-hero heights, masked in night. *Heaven spots* help me keep calm, focus and think and commune with the nature the city tries desperately to remove. But nature is more powerful than man. We are a part of nature and try so hard to be apart from nature, as if we could remove ourselves. I walk at night or during the day, I know the names of marigolds, violets and bluebells. I love when the lilacs bloom. But most of all I try to see the stars and when I can't, at least the skyline.

A structure appears.

JC

This is my favorite spot, the old Brach's candy factory. It is a museum writers' break in and bomb. It still smells like sugar. It's been abandoned for some time. I heard a company bought the land and threatens dynamite, but for now another writer has usually done me the service of snipping the fence.

JC

(climbing high)

JC climbs through.

I climb steps to the roof and take in the skyline Hancock to Sears, the city's lit crooked smile. It is so quiet. I come here to compose myself and when there are no stars, I am comforted by the stars man made. I think I need to hang a star of my own.

JC re-enters the apartment, joins Seven and the rest of the crew.

 JC
Yeah. Okay. I'm down.

 SEVEN
Word.

 JC
But not until the time is right.

 SEVEN
When will we know the time is right?

 JC
There will be a sign.

 ———

Transition to the crew together in Selena's car. Selena behind the wheel, Seven in the passenger seat, JC and Dose in the back.

 DOSE
(holding a pack of smokes)

Hey, Selena.

Selena ignores him intentionally.

 DOSE
Hey, Selena, turn the window lock off.

No response.

 DOSE
Seven, unlock my window, man.

 SELENA
Don't unlock the windows.

DOSE

What?

SEVEN

Why?

SELENA

I don't want him smoking in here.

SEVEN

How you know he's trying to smoke?

SELENA

You're trying to smoke, aren't you?

DOSE

Nah. Just need some fresh air.

JC

He's holding a pack of Newports.

DOSE

Snitch.

Slowly smoke starts to creep over the seats.

SELENA

PUT THAT OUT!!

SEVEN

Come on, D.

DOSE

Roll that window down.

JC

I'm allergic, please roll it down.

SEVEN

He is allergic to smoke. Maybe roll it down.

SELENA

Put that out first!

DOSE

On your seat?

A defeated growl from Selena. The window comes down. Dose sticks his head out and blows out smoke.

DOSE

It's snowing!

He brings his head back in.

It's snowing.

The snow starts getting noticeable.

 JC
Yo, this is beautiful.

 DOSE
I know you're an eccentric dude, man, but this is not beautiful.

 JC
But it will be. Once it's done and down.

 SELENA
I can't see a damn thing!

Seven turns to audience.

 SEVEN
(to audience)

Anytime it's unfavorable outside, that's when you paint. Fog or a
blizzard—it's like nature got you undercover. The falling snow,
the cars. The splashes. The slush. Car windows fogged up. Driv-
ers focus on the road. It's an illegal blanket.

—

Transition

 JC
I think this is the sign.

 DOSE
Hell, yeah!

 SEVEN
Love, what you think?

 SELENA
Yeah. Let's do it.

—

Transition

JC, Seven, and Dose address the audience. As they talk, they hold up items, demonstrate, display, etc.

SEVEN

Okay y'all, you're in this with us, so you gotta know how we do.

DOSE

Yeah, but don't go snitchin'. Cuz snitches get no . . .

SEVEN

Shut up, D.

Okay. First, always wear boxers.

DOSE

And mustard in your shoe tops.

SEVEN

(annoyed at Dose)

If you get knocked, they make you take off everything. Except boxers. So unless you tryin to go commando up in line with a bunch of other men. Definitely wear boxers.

JC

You want to remain agile, yet warm. We'll be out in a snowstorm. Layering is essential. Long johns, not sweat pants. Clothing close to your body, keep tight.

SEVEN

Two pair of socks.

JC

At least.

SEVEN

Cuz if you gotta crap somewhere the extra socks can be like toilet paper.

DOSE

Also, keep mustard in your shoe tops.

JC

Blend into your environment otherwise cops are gonna be suspicious.

SEVEN

The thrift store is your best friend.

JC

Three things you need to always keep on you to survive the urban wilderness: a lighter, a knife, and a condom. With a lighter you can light firecrackers or bottle rockets as a distraction. When you're right at the range of frostbite, fire for warmth. A knife for protection and if you get caught out there you can stab a critter or something and eat it.

DOSE

It's like *Survivor* out here, y'all.

JC

The condom is a waterproof bag. It holds so much.

SEVEN

You can fit a two-liter pop in a regular size condom. Why on God's earth do magnum condoms exist?

DOSE

(*Chuckle*) I know why

JC

I've had to ditch my phone, my wallet . . . Put it in a condom, throw it in the river tied to a rock. Come back and get it the next day.

SEVEN

Hats are good. Skullies or mailman caps. You can cut off a tee shirt sleeve and bring it down, over your face, it stays like a bandana.

DOSE

Gotta cover that grill, kids.

JC

I also have this thing called the vamp tool, which is a military escape rope with a tongue hook on it. If you need to get onto something or pull down a fire escape, a bucket of paint, a person, just (*whistle sound*) 2000 lb. work load. Tested. With properly tied knots.

DOSE

This dude is MacGyver, man . . .

JC

Oh and night vision goggles. You can get them at the Army Surplus . . . or Wal-Mart . . .

SEVEN

Normal gloves with rubber gloves over them.

JC

Could be kitchen gloves or them black rubber gloves you see tattoo artists with. But my favorite: gorilla gloves. They're made for grip.

DOSE

Mustard?

JC

Nope. Gotta talk about paint.

SEVEN

Look: I have three main colors, two accent colors. I label the tops of the cans, so I can grab them easy out the bag. 1, 2, 3, then there

might be b, g, r. Background colors, accents colors. Outlines and fill-ins. We always paint with the bag in the front of us, to ensure the paint is in order.

Our piece, it's based off the sketch. The idea we made in the safety of the lab.

JC
Never bring the sketch outside.

SEVEN
You might drop it or whatever. And that's evidence right there.

JC
Before we roll, we memorize: colors, fills-in, the shade and spatial relationships between letters and the pieces themselves.

SEVEN
But you also, kinda, plan for improvisation.

DOSE
Like Coltrane, Miles and them.

SEVEN
Right, maybe put in a cartoon character or street sign. Details. Small things you know. Bits, bits, little doodads that make the piece memorable.

JC
But you're only afforded time if you plan ahead. The attention to the detail and timing and gathering of all your supplies.

SEVEN
Gotta label your cans.

DOSE
Brings them caps!

JC

Caps are the funnel thru which the paint sprays. Different caps are like different brushes. Small ones, medium ones—

SEVEN

But your bread and butter is that fat cap.

DOSE

Astro Fats are dope.

JC

Astro Fat is a type of fat cap—the fattest. A softball size dot of solid color.

DOSE

I could paint this whole room in like five minutes with an Astro Fat.

SEVEN

Caps get clogged real easy. Always bring extra caps when you go out.

JC

If you don't have all the caps you need.

DOSE

You're fucked.

SEVEN

Pretty much.

JC

Respect and organize your tools before you head out for war.

SEVEN

All right, Dose, tell 'em about the mustard.

DOSE

Yeah. Let's say you *do* get caught. And they lock you in that hold-

ing tank. When they give you that nasty-ass bologna sandwich. You're the only motherfucker in there that's got some mustard.

 SEVEN
(to audience)

And there you have it. Okay, y'all ready?

 DOSE

Let's do this, y'all.

JC and Dose head off, Seven remains.

——

Transition

 SEVEN
(to audience)

When I was a shorty, I started drawing all these Chinese symbols. I'm not really sure why; anime, cartoons, Wu-tang albums, whatever, but . . . I would do—this symbol that looked like a "T" cuz my government name, you know—starts with a T, but it was in Chinese and it meant Qi, you know like Chi, like energy that flows through you. And when I first read it, transcribed in English, I read it as *Chi*, you know like Chi-town and I was like word, that's what's up, that's me, you know.

But then, one of the Asian cats I ran track with, and I'm not racist, but he, for real, lived in Chinatown, saw the tat I got on my arm in high school and was like, "7." And I'm like, "what" and he's like "7," on your arm, why "7" and like, I felt like and asshole right, I mean I didn't know if he was being funny or whatever. But he said the Seven symbolizes togetherness and means air or breath and that it's a lucky number because the seventh month of the Chinese calendar is called the "Ghost Month" cuz hell is closed and all the spirits hang with the living, and I was like . . . "Oh word! That's dope." And I remember, I went home and told my mom and she is deep into astrology and numerology and she freaked out saying that 7 is of course G in the alphabet and is

associated with G-d, so she knew, she said and she said this, for real, she said she knew then, that I'd be safe.

And I believe that too. That no matter what, I'll always be safe.

—

Transition to LOH in the car on the corner of Columbus and Monroe, across from the Modern Wing. Snowing like mad. They are fixated on something in the distance.

SEVEN

Yo, when are these two gonna bounce?

JC

Any minute now.

DOSE

Want me to go over there and scare 'em away?

SEVEN

Who makes out in a snowstorm?

JC

They're gonna bounce soon.

SEVEN

Here come po-po, get down!

They get down as faint headlights pass by.

JC

That was just a taxi.

SEVEN

Where the hell is this third snow truck?

DOSE

It's only been like 17 minutes since the last one—should be soon.

SEVEN

I ain't seen any cops.

JC

Not good. No rotation means it's sporadic.

Seven taps his earpiece.

SEVEN

Selena, let's test 'em out again.

Selena nods.

SEVEN

(into the earpiece)

1, 2, 1, 2 this me.

SELENA

(into the earpiece)

I hear you, 1, 2.

SEVEN

You sure about them cameras, man?

DOSE

Of course.

SEVEN

Did you check?

DOSE

Yeah, my guy said they been out all week. Repair dudes don't come til next Monday.

They sit silent, waiting.

SELENA

There's a person in that car up there.

 JC

(holding binoculars)

He's sleep.

 DOSE

Or dead.

 SELENA

When y'all get out I'll park behind him, so if he wakes up and starts getting nosey we can bail.

 DOSE

Yo, here comes the snow truck.

 SEVEN

They are still makin' out in the park up there.

 JC

We gotta move. This is our chance.

The snow truck goes by.

 JC

This snow is comin' down crazy, they won't see us.

 DOSE

Come on, Sev.

 SEVEN

And you're positive about—

 DOSE

Yes! The cameras are out!

Seven looks at them. Nods.

 SEVEN

Let's do this.

Seven, JC and Dose get out with their backpacks. Seven speaks to the audience, as the three walk swiftly to the wall.

SEVEN

We walked down Monroe heading west. We moved quick, with purpose but felt an increased sense of calm. We ducked left behind the little wall and Selena whipped the car around behind the guy who was sleep or dead, right at Columbus. She's facing us so she can peep the whole area—that corner, Monroe, cars coming from lakeshore, anyone walking or coming out Millennium Park for some reason during a snowstorm.

Selena in the car, watching. Lo and behold, a cop rolls up. The cop knocks on the glass. Selena turns to the audience.

SELENA

Okay—so if you're gonna be a lookout you gotta learn how to deal with the cops. It's just par for the course. Cops are gonna drop in on you. You're not doing anything illegal. Suspicious, sure. But not illegal. So don't act guilty.

COP

Know anything about that pulled down fire escape?

SELENA

No sir.

COP

What're you doing here?

SELENA

(to the audience)

My check engine light had been on all week so—

(to the cop)

Well my car just won't start. I'm sorry. See, my Check Engine Light is on. Triple A is coming. I'm sorry.

COP

OK. We'll come back in a little bit and check on you.

SELENA

(to audience)

There was this other time.

COP

What are you doing here?

SELENA

(to the audience)

Usually I'd just kind of act stupid.

(to the cop)

Ohmigod is that not okay?

(to the audience)

And then there's tonight. Big snowstorm. A young woman by herself on Columbus Drive.

COP

Ma'am, do you need some assistance?

SELENA

(to the officer, fake crying)

I'm sorry, I just had a huge fight with my boyfriend, who's a jerk and we live together and now I am just thinking about where I can go *(increasing tone and speed)*. My sister lives further north but her husband is an asshole and all my friends told me this would happen and now I just need a minute to figure things out like, like, like where I'm gonna go? What I'm gonna do. You know he said he loved me but he doesn't, you know, men are such liars. I really just need to sit in the car right now. Please just leave me alone. Please just leave.

COP

Oh, OK, ma'am. Sorry.

The cop exits.

SELENA

(to the audience with a smirk)

Drama camp. Three summers in a row.

(into the earpiece)

You're all good, boys.

—

Transition. Seven, JC, Dose are off to it.

They work, paint, fluidly and energetically.

SEVEN

(into the earpiece)

Selena, how we lookin' now?

SELENA

Three more minutes.

JC

Let's hurry it up, guys.

SEVEN

I know man, but ... *(looks at the wall)* ... we put in a lot of work!

DOSE

This lookin' crazy, yo! I wanna fill-in with our crew letters tho ...

JC

I don't think we got time, D.

SEVEN

I got one more tag I'm tryin' to do, Jase.

DOSE

Yeah we lettin' all these sucka ass crews know. LOH all day. We kings, Jase, we gotta let 'em know who's knockin'.

SEVEN

Duck! . . . Selena, I thought you said the snow plows hadn't turned.

SELENA

(into earpiece)

Those were *salt* trucks babe, and they came from the west, I couldn't see them before you did.

SEVEN

We gotta go, y'all, now or never.

JC

The salt trucks run in pairs ...

SEVEN

Duck!

JC

You see those cameras?

SELENA

Two minutes!

DOSE

They can't see us, Jase. We on our ninja shit tonight.

SEVEN

I think we good man ... but D, don't take off your mask, like last ...

Dose pretends to pull his bandana down.

JC AND SEVEN

Stop!!

DOSE

I'm just messin' around y'all. Chill. We good out here. Plus it don't matter, the CAMERAS IS STILL OUT!

JC

The museum dude still in the window?

DOSE

Naw, he walking away.

SEVEN

Jase, I'm busting this tag.

DOSE

Me too, man.

JC

All right, but wipe down the cans before we leave.

DOSE

I haven't even touched 'em, man.

JC

Be smart, D. What if one of us did?

Dose reluctantly starts wiping down cans.

All turn and see what they have done thus far.

SEVEN

Fellas, we are really bombing tonight. This ain't no quick burner this is like—Holy shit! I mean look at this.

SELENA

(in the earpiece)

One more minute, guys.
Everyone stops and backs up a few steps to take in their masterpiece.

SEVEN

It's not done, though.

DOSE

Hell, naw.

SEVEN

Jase, you finish. Your hand style is cleaner.

JC

No, homie, this is all you tonight. This is what you've been dreaming about . . .

SEVEN

For real?

JC

Make it legible, though. So the people can read it.

Seven goes to the front of the piece and Dose is at the end. Seven writes THIS IS MODERN ART. Dose writes LOOK OVER HERE.

JC

It is so chill right now.

SEVEN

It's eerie, man.

JC

There's no one here. No cops, no trucks. Ghost.

SEVEN

Hand me the camera, man.

JC

You think we got time?

SEVEN

You see anyone here?

DOSE

Y'all are crazier than I thought . . .

SEVEN

I hope the snow don't mess with these.

JC

Hold steady, Seven, get each piece.

SELENA

Seven, let's go.

JC

Get each piece, man.

SELENA

GUYS!

DOSE

Oh, shit. Sev's on some victory lap shit, man. This dude on a victory lap my g, craaaaaaazzzzzzzzzzyyy . . .

JC

(Watches Seven, then to Dose.)
It's not a victory until seven years from now.

SELENA

Let's go. NOW!

The piece appears in low light as the stage empties. Night becomes day and slowly the ensemble as pedestrians begin to fill the stage, looking at the piece with varied reactions.

———

Transition

RESPONDER #1	RESPONDER #2
Oh my God	Is that supposed to be there?
My God that's not that's not	Whoa?
that's not	That is too cool!
I don't think that's supposed to	There's no way—There's no
be there at all	way—There's no way—
Who authorized this	There's just no way
This couldn't have been com-	There's no way that could've
missioned	Been invited to do this by the
"This is modern art?"	museum
What?	This—Is—Modern—Art
Seven. Dose. Jase	Look Over Here?
"Look Over Here?"	

A swift transition to the Crew. Throughout this section the audience should see both the reactions and the crew responding to them.

DOSE

Yo, turn the TV up, fam!

SEVEN

What's up?

DOSE

We made the news.

NEWS ANCHOR

Was it a blank canvas that needed to be filled, or just a wall that didn't deserve to be vandalized?

SECOND NEWS ANCHOR

Either way the Art Institute of Chicago is spending the better part of the day sandblasting off a 50-foot long graffiti mural from the East wall of the new Modern Wing.

The crew cheers.

RESPONDER #3

I was out for a jog this morning and hell I thought twice about it cuz the weather was bad but something told me to get myself out there and I am glad I did. 6 am. I'm coming up Columbus and boom! It hit me—these big colorful names.

RESPONDER #4

I missed it! Man! Damn graffiti blasters. Can they just let it fly for five freakin' minutes! I woulda loved to have seen that.

SELENA

Check this out, guys! They're talkin' 'bout you on twitter.

@SONOFBELUSHI

(played by One)

Finally we can see art at the Modern Wing without spending $18!

@ARTSNOBCHICAGO

(played by Two)

I wasn't too impressed.

SELENA

You're all over Facebook, too.

RESPONDER #5

Graffiti is so 1970s—doesn't this generation have anything unique to contribute?

SELENA

They talkin' 'bout you on the call-in show.

RESPONDER #6

This is misplaced creativity and self-indulgence personified. Graffiti is not just writing on a wall. It is a social attack. It might be $5000 worth of damage to the wall but the psychological effect is immeasurable.

What if I robbed you with a flamethrower rather than a gun? It doesn't make it any less of a crime, nor does it change the act of vandalism to art.

DOSE

Damn! People throwin' all sorts of shade.

SEVEN

That means it worked.

NEWS ANCHOR

For students at the Art Institute, the graffiti is art in the real world; something to be photographed with cell phone cameras and debated.

STUDENT

Not bad—it's pretty basic—I mean, I know they did it in a snowstorm and all.

SELENA

But you're getting some serious love out there too, guys. Listen:

SELENA	RESPONDER #7
(reading off the screen)	
Finally!	Finally!
Somebody making some real art	Somebody making some real art
For the people	For the people
I see you out there	I see you out there
LOH all day	LOH all day

JC

Wait. Listen to this, y'all.

NEWS ANCHOR

The museum's public affairs director has released the following statement:

PUBLIC AFFAIRS DIRECTOR

The graffiti has a good use of color but is being treated and removed from the limestone which may now be permanently damaged as a result. It's disappointing of course but it's the price of doing business in the big city. The Art Institute does have a collection of graffiti it prefers to keep inside.

NEWS ANCHOR

The entire act was caught on tape by the Museum security system, and Chicago police are investigating.

ALL

Oh shit.

Everybody looks at Dose.

DOSE

Guess my guy was wrong.

Quiet.

DOSE

Whatever, bro. What are they gonna do? I mean. We was on our
ninja shit. Even if they—

SEVEN

And you were out there messin' around with your bandana.

DOSE

Nobody saw us. They got video of what? Three dudes in masks.
Calm down. Why are you all scared?

SELENA

What if they got my license plate?

DOSE

No way. You weren't even in the range of those camera. Were you?

SELENA

I don't know. I didn't check because somebody told me they were out!

JC

They would have been at our door already if they had us on tape.

SELENA

Right but if they tracked the plate then—that car is in my parent's name!

Selena whips out her phone to call home.

DOSE

Relax, Selena, they ain't—

JC

GUYS! Listen.

SECOND NEWS ANCHOR

If anyone has any information that could help in the apprehension of these vandals, please contact the Chicago Police Department at the number below.

Seven's phone rings. Then Dose's phone rings.

SEVEN

Somebody's gonna snitch.

DOSE

Ain't nobody gonna snitch.

JC

Guys . . .

SELENA

(into the phone)

Hello mom, uh, it's me, uh—gimme a call when you get this.

SEVEN

You ran your mouth about this, didn't you, Dose?

DOSE

Nah. You were the one running around on ladders.

SEVEN

Shut up, D!

JC

Guys . . .

SEVEN	DOSE	SELENA
We're gonna get pinched man When we was planning You were running your mouth To all the other crews about how you were gonna do something big at the Art Institute and they're gonna snitch.	Just chill, man This ain't my fault. My guy told me that the cameras were out. It's not my fault. I didn't tell anybody. I didn't tell anybody. Don't you turn on me, man. Chill. This was your fuckin' idea, okay? This was you—	Guys. Please. Can we talk about the fact that it was my parents car and if they have the license plate on tape I am done for? My whole life is over. Can you all stop thinking about yourselves for a second?
It's your fault what if they get her license plate		

JC

ALL RIGHT! Everybody. CHILL. We gotta make moves. Even if they have tape or don't or somebody tips off the cops or they don't—from here on out—we gotta lay low.

Nobody moves.

SEVEN

Right. He's right. As of now we need to lay lower than low. Underground for real. Somebody is gonna drop some little seed that grows into a full on indictment. If they are going to come for us, we gotta stay steps ahead. We got to clean shop. We got to get all this shit outta here. Let's go! NOW!

The crew bursts into action, filling bags—chaos—bodies trying not to run into each other.

JC

(in the midst of the action)

Everything: Our books, pictures, paint. Our clothes. Gloves. Caps. Everything. Cameras. Memory cards. Computers. All of it. We got to get it all out of here.

Finally all four are loaded up and ready to rock. They all look at one another. They knew this day might come. And gradually, one by one each departs in a different direction leaving only Seven to speak to the audience.

SEVEN

Every writer, the smart ones at least, has that exit strategy mapped out for when the day comes. We were no different.

I was homeless there for a while. I mean I wasn't out in the streets. I mean I was sometimes and sometimes I'd just spend the night riding the train or one time I fell asleep at the gym, couch surf til folks got tired of me eatin' all their cereal.

The whole time Selena kept encouraging me to stay with her and her family and after. A while there, I finally gave in.

—

Transition

A random Tuesday night dinner at Selena's. Forks scrape. Selena, Selena's dad, and Seven.

 SELENA

How's work?

 SEVEN

You know my job sucks.

 SELENA

Yeah. I know. You say it constantly. I was talking to my dad.

 SELENA'S DAD

My job sucks, too.

A laugh.

You know Te—

 SELENA

(cutting him off)

Seven, Dad.

 SELENA'S DAD

Yeah. Right. You know, Seven. Uh. Friend a mine—we went to
grammar school together—he has a real successful business.
They paint houses.

 SELENA

Dad.

 SELENA'S DAD

What? Kid said he hates his job. Thought maybe he'd be inter-
ested in—

 SEVEN

Pardon me for a minute, y'all.

*Seven excuses himself from the table. Selena's dad and Selena sit in
uncomfortable silence for a moment.*

SELENA'S DAD

What?

Selena just shakes her head.

SELENA'S DAD

You talk to that lawyer yet?

SELENA

Why would I need a lawyer?

SELENA'S DAD

Look, I believe you. You say you didn't do anything.

SELENA

I didn't.

SELENA'S DAD

But your mother is convinced you had something to do with that Art Institute mess.

SELENA

A mess?

SELENA'S DAD

Just—talk to the lawyer—so your mother can cool her jets some.

SELENA

You sure it's just mom?

SELENA'S DAD

Look. We sent you to Catholic school. You know right and wrong. It's your life.

Selena drops her napkin and gets up.

SELENA'S DAD

Hey, kiddo.

SELENA

Yeah.

SELENA'S DAD

There is such a thing as guilt by association.

SELENA

Hell's that supposta mean?

SELENA'S DAD

It's not that I don't think that Te—

SELENA

Seven, dad.

SELENA'S DAD

He's a good kid. I'm not racist or anything but—

SELENA

Can you please just relax? We didn't do anything.

SELENA'S DAD

Did you not do anything? Or is there no *proof* you did anything?
There's a difference.

Please just speak to the lawyer. For your mother.

*Selena heads into the next room to find Seven packing random things
into his backpack. No response.*

SEVEN

Your parents think I am a criminal.

SELENA

They like you. They just. They watch the news. Get all worked
up. My mother really.

SEVEN

I overheard your dad talkin' about a lawyer.

SELENA

They're trippin'. It's been almost a month. Nothing.

SEVEN

If my family could afford me a lawyer I'd get one. Just to be prepared in case—to know.

SELENA

My family can't afford one either.

SEVEN

Come on, Selena.

SELENA

What?

Sev. What?

SEVEN

(lowering his voice)

Let's say we got caught. You'd get a slap on the wrist. Me, JC, Dose, we'd go to prison. We got records. You don't.

SELENA

I'm in this with you, Seven.

SEVEN

You know what they love to do in Illinois? The whole country, really. They love to lock up Blacks and Latinos.

SELENA

Oh, don't be so dramatic.

SEVEN

You got a good home here. And however you wanna downplay it. You should enjoy every second of it.

SELENA

I can't let you sleep on the street.

SEVEN

You know I got love for you. But I can't *live* here.

SELENA

Sev.

SEVEN

Thank your parents for me.

Seven goes for the hug. Selena is a statue of folded arms. Seven goes for a kiss, she shifts her body. He backs up. She turns to him slightly. They exchange looks—he finally exits.

—

Transition

Seven speaks to audience.

SEVEN

What I didn't tell her is that I actually had a new spot.

Real small, real simple—in a part of Chicago that wasn't exactly on the tour. I told nobody. Not my Mom. Not Jase. Not Dose. I hadn't seen those guys since we left the apartment. I felt completely isolated.

Seven is in this spare, small new spot.

It was me. An easel. Two paintbrushes. A palate. Some acrylic paint, a few canned goods, an ipod, and my thoughts. Night time was the hardest. After work. Walking through a city of potential canvases. A postindustrial city like this, a city constantly evicting, downsizing, and forgetting. A city constantly advertising and flaunting—My fingers stay twitching with desire.

"Just a tag real quick." But I gotta lay low, stick to the game plan. I'd never gone this long before. And trust everytime I thought "I got

this. Just a small one." I'd hear it on loop.

POLICE PR REP SEVEN

The city of Chicago is actively
pursuing these vandals and
intends to sue them in the
amount of one million dollars.
(*lowering gradually in volume*)
Chicago is pursuing these van-
dals Intends to sue them
Chicago is pursuing these
vandals
Intends to sue them
Chicago is pursuing these
vandals That itch would subside
Intends to sue them And I'd put one foot in front of
Chicago is pursuing these the other
vandals Squeeze the lint in my pocket
Intends to sue them Until it would stop
Chicago is pursuing these And I would continue to com-
vandals pose large scale in my mind
Intends to sue them

SEVEN

Day didn't go by where I didn't wonder if JC and Dose had been
going through the same thing.

JC is in the same heaven spot atop the Brachs' Candy factory, painting.
A figure gets closer. It's a security guard. JC hears him. Stops. There
is a moment of standoff. Then a second security guard appears. Then
they all take off running.

JC steps out of this chase scene to speak to the audience.

JC

They run *after* me. They're playing follow the leader. They're not
going to catch me because I'm running. They're running but I
have the layout of the train or the store or the yard or the building
embodied within me. I see the world like that. I see the entire grid,

all the patterns and angles. Patterns and angles dictate outcome.

My father is an intelligent man. He taught me to remember things. To visualize and remember. He spoke of the ancient orators. They'd do things in their mind because paper was rare and expensive. They would build a building and in that building was a concept and within that concept were the items in that room. The mapping, the seeing, the plotting, I get from my father. But my mother made me develop the nerve. She almost died a dozen times. She'd have seizures. The world doesn't stop when this happens. If you're sitting there like *oh shit, she's having a seizure and I'm frozen* or *oh shit they're going to catch me and I'm frozen* . . . bad things will happen. I came here knowing what I'm going to do. And I'm going to do it. I'm going to make my moves like it was a chess game. Everything is timed and planned. I'm steps ahead of cops or security . . . or whoever. You can't beat me in a foot race. At some point we're gonna run this out, and I promise, you're not

gonna catch me. They will never, ever catch me.

JC jumps off the building.

———

Transition to Dose, finally addressing the audience.

DOSE

Right after our Art Institute piece went live, we got some really bad news . . . an ill writer died. I didn't know him. I knew his pieces but I never met him. He wrote SOLE, UAC and FTR crew. I used to see his pieces everywhere. His tags was dope, well balanced, he didn't elaborate with a bunch of bullshit.

They were like . . . working class tags. Something the average person could read. Cops chased him off a roof and he ran and jumped into the river right near the Damen Silos. He drowned or died on impact, something. It messed with me.

Don't get it twisted. I love writing. It gave me every brother I never had, you feel me? I lived for the shit. But I ain't tryin' to die for it, you know . . .

I entered this contest some energy drink was doing. You had to incorporate three things they gave you on a 10 x 10 canvas: the dumb can of the drink, the colors of the Chicago flag and some picture from our childhood. I flipped the whole script, cut a bunch of cans and an actual Chicago flag into strips and weaved the shit all together to make a crazy backdrop that kinda looked like a distressed wall with paint chipping off. I stuck this cute picture of me as a little ass kid in the middle of the canvas and painted a crown on top my head and over the picture I wrote *All-City* and under the picture I wrote *King* in a clean-ass hand style . . . and ah . . . I fucking won.

There were shit tons of artists who entered and I won, yo. I was like, daayyyyyyyyyyyyum. Homie they paid me $5000, and now this company got me doing other things: I just did a mural for them near some shoe store that just opened and they gonna fly me to

Miami for some like art and food conference like Art Basil or somethin' corny like that.

I'm startin' to get paid to sign my *real* name to pieces. No one knows I bombed the Art Institute, except for y'all now, I guess. I had to do that anonymous. But now folks are starting to get to know *me*, the *real* me Jason "Dose" . . . ah . . . (*laughs*) you thought I was gonna snitch on myself . . . y'all crazy yo . . . I *still* ain't no sucka. I just like signing my name. My real name. For real tho, I like it a whole lot better.

—

Transition back to Seven's shack.

He's on his Bob Ross shit—painting at his easel, simmering, thinking.

SEVEN

I don't see too many people. I go to work, the gym, back here. I don't use the phone much, cuz I think folks is listening . . . you may think that sounds crazy, but . . .

They made graffiti an act of terrorism after 9-11, homeland security, the whole nine. The art we make, the government, this city, considers it terrorism. It's like this whole city is a prison. Why you think the schools and roads are bad? They want us out of here.

Treatin' us like criminals since the day we were born. It starts to mess with your head.

Knocking at the door. Seven leaps up, grabs a baseball bat. Hella cautious. Opens the door. Selena with a bag of groceries.

SEVEN

How'd you find me?

SELENA

That's the first thing you have to say to me?

SEVEN

You alone?

SELENA

Seven.

Seven looks over her shoulder.

SEVEN

Come in. Come in.

Shuts the door behind her. An awkward hug.

SELENA

You can put the bat down, Joe Clark. Brought you some things.

SEVEN

Thank you.

Seven starts removing the nonperishables.

SELENA

You hear about Dose?

SEVEN

What? He get caught? They got him?

SELENA

Relax. No. He's doin' real good these days. Like, doin' permission walls and art shows.

SEVEN

Good for him. So you seen him around?

SELENA

Yeah, he was part of this exhibition at the Cultural Center and he's going to Art Basel.

SEVEN

(*handing her a half empty grocery bag*)

Here.

Selena looks at it puzzled.

SEVEN

No refrigerator in here. This stuff'll just go bad. Thank you, though.

Long stretch of quiet.

SEVEN

Look. You can't—It's just that. Somebody coulda followed you.

SELENA

I'm leaving—Chicago. I came to say goodbye.

SEVEN

Where you goin'?

SELENA

Probably better if you don't know. Right?

SEVEN

Yeah. Right. Did you tell Dose where you're going? Since you two are tight now.

SELENA

Are you joking?

SEVEN

It's whatever. Y'all can do what you want.

SELENA

Thanks for the permission. Asshole.

Selena starts to exit, stops, turns.

You think I'm some silly white girl who doesn't know what she got herself into.

SEVEN

SELENA

Oh don't gimme that. It ain't about that. You bein' white. We're the ones with the cans in our hand. We're at war. Selena, a year or so ago you didn't know shit about this. Now you feel like you can just dip a toe in and out whenever you get the notion to. You decide. No. No.
"Oh, remember when I used to drive those graffiti guys, I miss that, Oh hey Dose—"You have no idea the type of shit that we are up against—
No. No. You think you can just come and go as you play—roll up to me spot—matter of fact I'm gonna have to move again!

Yeah, Seven. I know, but that doesn't mean—
That doesn't mean—

It's not like that at all—why're you talking to me like I'm some kinda—

Stop it! Stop talking to me like—
I just came here to say goodbye to you.
I came here to say goodbye. I brought you groceries Stop! Stop!

Selena grabs the bat and hits the bag of groceries, sending the perishable fruit inside splattering across the room. Selena sees the mess she made.

SELENA

Shit.

She drops the bat and kneels down to start picking up the bits and pieces. Seven approaches.

Seven leans down, grabs her by the shoulders, and eases her back to her feet. He gives her a true hug. She drops the random pieces of fruit in her hands and hugs back.

They release.

<p style="text-align:center">SELENA</p>

Can I ask you—will you be honest—

<p style="text-align:center">SEVEN</p>

Of course.

<p style="text-align:center">SELENA</p>

It wasn't just because I had a car, was it?

<p style="text-align:center">SEVEN</p>

No.

<p style="text-align:center">SELENA</p>

Okay.

The ridiculousness of the question is felt in addition to the fruit splattered floor and Seven's refrigeratorless shack. Finally they both smile a little.

<p style="text-align:center">SEVEN</p>

I mean, don't get me wrong, the car didn't hurt.

<p style="text-align:center">SELENA</p>

Don't make me get that bat again.

Finally a laugh. Small. But nonetheless.

<p style="text-align:center">SELENA</p>

See ya 'round, Sev.

SEVEN

Goodbye, Selena.

She exits.

The audience sees Seven clean up the mess. A few pieces of fruit made it out alive. He looks at them. Puts them in the one bowl he owns. Sets them on a small table. He puts a new canvas on his easel and begins to paint a still life of the fruit in the bowl.

SEVEN

(to the audience)

This whole damn time and I can't even tell you my real name. If I told you our names, and you didn't turn us in, you could go to jail for concealing the identity of those who committed a crime.

(Laughs)

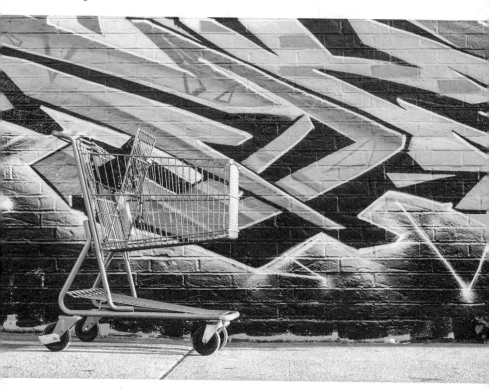

If I do I'ma end up in one of those prisons they stay building for people who look like me. The statute of limitations, still in effect. It lasts seven years.

I miss my people. I miss the streets. I miss bombing, being out in places they said we couldn't reach and attacking it. You probably wondering if I thought it was worth it. I mean—here I am. No crew, no girl, no aerosol cans. Just me and some rotting fruit.

I'll put it to you like this.

We wanted to make a statement, to change history, to fly our letters in a world they would never have writers or artists that come from where we come from. We wanted people to notice. And they did. I think more than we anticipated.

I remember, that night, JC said to me. We'll probably be the only artists who'll EVER be on the outside of the Art Institute. If we were inside we'd be one of many, but we were on the outside. We were up so the whole city could see. And we are the only ones to ever do that.

———

Transition to flashback to that snowy night in front of the Modern Wing. LOH crew stands in front of their work.

After a few moments, the Chorus enter the stage to join them. Everybody looking at it. The lights shift—we no longer see the people, just the piece.

After a moment the blaster clears it. Now we just see a blank wall.

Lights out.

END OF PLAY

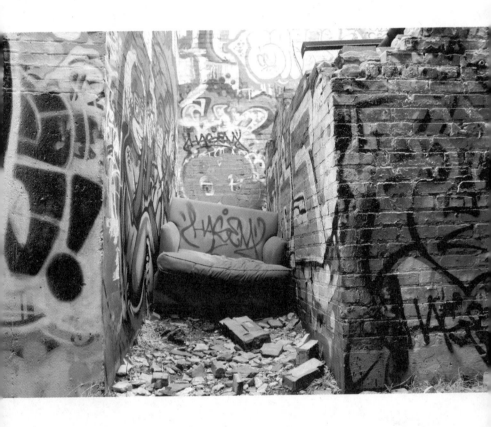

An Outlaw Afterword:
Cinderella Story

On art, love, and becoming "Free Radicals"
with the real Seven, JC, and Selena

Moderated by Kevin Coval
This conversation was had over a year after *This Is Modern Art* premiered at Steppenwolf Theater, in May 2016, at a cafe on the north side of Chicago with the real people the characters Seven, JC and Selena are based on. I cannot print their names because as of the publication date, the statute of limitations is still in effect and their freedom necessitates anonymity.

SEVEN

Me and JC decided a long time ago, together, that we were painters, like for real, for real. It was something we wanted to

do forever. If we did it to the point we wanted to do it, we would just naturally be some of the greatest painters that ever lived. Not in the sense that that was our goal. Just that's—

JC

That's just what will happen.

SEVEN

If we painted well enough that's what's naturally going to happen. This play and all of this that you made happen, just made it real. Way fast—like it definitely motivated us. Completely motivated us. Because we would've been willing to do what we're doing with no motivation whatsoever. Still wake up (whenever) to paint, worst of times. So now, if anything, we have the ultimate reason to continue doing what we decided to do.

JC

If you think back even a little bit, we were just riding around in the car smoking blunts and stealing paint to do this for free. So...

SEVEN

It's insane to me how much time we put in graffiti. Looking back on it—now that I paint. So much time and money.

JC

It's hilarious because people now take stock in that singular event (more) than any piece of graffiti we ever did.

SEVEN

Exactly. It made it all completely worthwhile. There were personal investments. Every single one of those nights we painted. You know? Every single night. It was college. We were in school. We were working and learning and not just painting... the discipline of planning... the teamwork. All of it. All of it had to work.

JC

It was almost beyond a dissertation, like we crossed through some sort of a metaphorical threshold that no one else could've brought you to, you know? Because then it wasn't study anymore. And seven years later it's still the reiteration of the same conversation.

SEVEN

We still do the same thing, in a different way.

JC

And if you asked a psychologist, this would be a complex, right? Like this is a problem.

SEVEN

Oh, I'm definitely obsessed.

JC

When the reality is that it's the reverse because we really created a pivotal point in people's understandings of a) people, and b) personal property and how they relate to that, instead of discounting humanity in a black and white, red fashion. Accounts accruable, accounts accountable and receivable. I think that's really our overall greatest mission, to really spotlight how shitty the world treats everybody else.

SEVEN

And I feel like it's evolved. Especially for me, in my painting and in how I'm approaching art. Now it's more about how people respond to the art, or at best like if they can interact with it. That's actually a big fucking deal. And I realize graffiti was touching on that idea, but almost from the opposite end. A little bit more aggressive. But we weren't painting to put it in the gallery, to hang it up. It was in your face. Now some of the projects I'm working on, I'm trying to get people more involved with the art directly versus it just being like *hey look at me, I'm pretty*, you know? And that's a cool aspect. And I remember you (JC) actually kind of introduced me to that first. Remember when you wanted to do the

missions for the kids? And I remember thinking like, okay, like you said something along the lines of like *we paint all the time, we might as well paint things that make people feel good.* And that level of interaction. That was important. I think that was extremely important in my development.

JC

That's the thing, because knowledge that pervades through the system in such a way—is vast. Through so many varying degrees, but even in classical settings there's no true way to discern what your passion is going to lead you into, and therefore you end up in these weird, almost traffic jams of thought when in reality you know it's like *hey we're over here,* kind of like chemical free agents and we're creating different bonds, at no cost to anybody. And it's like *you can do this too.* It's not like we're exempt from natural law or anything. We're free radicals and you can be that, too.

KC

So, if you can think back a little—when you first saw the first thing in the play, what was that like? I mean I remember we had to sneak you all in to opening night . . .

SEVEN

It was unreal.

SELENA

Yeah, it was really surreal.

SEVEN

Unreal, like . . . unreal, like the most humbling experience I've ever had, for sure.

JC

It's crazy—usually artists never get to experience any level of rejection or acceptance. And if they ever do it's posthumous. But we got to see a cross-section of the world in one room that would've never been in the same place for any other reason, which to me is a wonderful thing. Like you took something that most people

consider gutter trash and you put it in a marble building, you know? And I went to the bathroom and I saw someone in Jordan's next to someone in like Gucci loafers and they were taking a piss in the same row of urinals. And to me that's what the world needs more of. Because it's like you guys still bought this shit in some store. You gave someone money that made that and they might not have been the same people but you know for a moment they shared that same space. And elitism didn't matter. You know?

SEVEN

You know it's really crazy, man. I remember watching it the whole time and I kept thinking about *Peewee's Big Adventure*. That's been one of my favorite movies since I was a very little kid, one of my first favorite movies. And if you remember, in the movie he has this crazy adventure because he loses his bike—or it gets stolen. So he goes to get his bike. All this crazy shit happens. But at the end of the movie they make a movie about his life because he met so many people and it was so crazy. And he's sitting there at the end of the movie with his friends and his girlfriend. They watch the movie and there's all these characters playing them. Like they have like this buff dude playing Peewee. It's so weird. And I watched that movie my whole life. So to some degree, subconsciously, that was like the situation. It just happens to you when you grow up and you're great or something great happens to you. For us to be sitting there and have that happen was just out of control. There was a part of me, like the child in me was like, *what?* I just couldn't believe it. This one night that we painted graffiti brought those many people together to have a discussion. That's insane. You know like that's insane.

JC

I can't even tell you how much graffiti I've done. It's almost like I've got cognitive dissonance to how much graffiti I've done. How many sketches I've done. How many iterations of the same thing that I've done. And for some reason it was just this singular one. And if that's not art—

SEVEN

. . . and it wasn't even a long one. We were out there for like 15 minutes.

JC

If that's not art, I don't know what is, you know? Like on some real shit. It's not about the appearances of things. Art seems to be a truly masterful language that is geopolitically, socioeconomically free, in terms of ideology. There's no red tape. It's not possible. You can't prejudge someone based on something that you can't truly fathom in its fullest form at that exact moment. So it's kind of like a nervous system manipulation of empathy. But we're kind of like socially responsible about it in that way. Because we did it for people, instead of against people.

SEVEN

Which I was always really glad about that. Because there was times in the past, you know, some of the quotes, you know, like there's so many things you as a graffiti writer can put on that wall once you're done with your piece. And we really—we were mature that night and I think that was the most important part. I really think that was important. Like somehow to be respectful in your defacing of this wall. [Laughs] Really important. Because it would've been received in a different way had we [written something other than Modern Art]—you know what I mean?

JC

It's something I think I've always said: graffiti is an imposition on the mind and if you're going to take the time to articulate an imposition, it better be fucking good. Let's not be the people that cried wolf, you know? I think that's important.

KC

Word. And for you, Selena?

SELENA

You know, obviously I'm not an artist. But it was really cool to watch this story unfold again and realize—just like—I started

doing this when I was 18 year old. So it really taught me who I was. It taught me that naturally I'm not an artist but I am a nurturer and I'm a guardian. And I love these people, so I wanted to be there because I felt like if I was there, they were safe. And ironically, the only times I wasn't there were the times they ended up in jail.

SEVEN

[Laughs] Very true. Very true.

SELENA

So it taught me about myself. They got this really cool art experience, to mature, and go from graffiti to oh shit now I can't do graffiti because I'm going to get arrested for it, so now I have to move my art elsewhere. As opposed to me, it was just like a big adventure in getting to know myself. And then watching it—I was like, *oh, shit.*

KC

How did it feel hearing the play, given that so much of the language was your language directly taken from our earlier interviews?

SEVEN

I was thoroughly surprised.

SELENA

It was so cool.

SEVEN

It was like we were dreaming because when you dream you don't really see faces. Seriously. Like had we been at the play on some drugs—[Laughter]. It felt like a dream. It really felt like a dream.

SELENA

So much credit goes to you and Idris (and Steppenwolf Theater) for being able to take our words and then cast people who you thought would do it well. And to see it the first night, you can see

us in there because of what you guys did. And then because we saw it multiple times throughout the whole run, you would see the actors change and become more and more like us.

KC

And what about y'all's response to the response? Once the reviews started coming from the *Trib* and *Sun-Times* and then the overwhelming response and power of the people's clapback—what was your experience of that?

SEVEN

Well, overall I was happy there was a response, you know? Love it or hate it, it's great. I feel like that's better than if everybody just liked it. You know what I mean? That would've defeated the purpose. It wasn't something that was supposed to just be liked, you know? I'm always skeptical of when I feel opposition to things. Because I know there's usually bias. Let's say with cops for example, I try not to just assume they're going to be terrible, especially considering I'm doing crime. I try to keep it even in my head. But when all the reviews came out, I was actually surprised there was such an opposition to graffiti. There was this one dude that was like they should have their hands cut off and they should be jailed forever.

JC

Castration. I remember that one.

SEVEN

Yeah, somebody said chop their nuts off.

SELENA

And for it being a play, an art form about another art form, it made you see how conservative and vanilla the people who are able to actually comment on these things in a public space are. And then it got the conversation started with other people . . . and I think it had the potential to kind of shake up who has a public space to speak about these different art forms.

SEVEN

You definitely shook things up. Like I didn't expect that. And it was weird because let's say it was something about race, you know? Or politics, that wasn't too heavy. A lot of people would just hush. They would disagree with it silently because they didn't want to look a certain way publicly. The fact that people were so unaware of how quasi-ignorant they were responding to this was insane. It was kind of amazing—

KC

For those few weeks did you all feel kind of like you were reliving some of the vitriol or exuberance that existed when the piece itself went live six years ago?

SEVEN

I was obsessed. I was online reading everything. I read every single article that ever came out about it. Everywhere. Every single one. I'm sure of it. Like yeah I was obsessed. Obsessed.

JC

I had a similar enthusiasm but I didn't have the same reaction. I suppose it was more something that kind of brought me a little bit deeper into myself and deeper into my own solitude. Actually, the only times I was out in public is when I was with y'all, in those weeks. And I came to some really interesting conclusions about people. Just generally.

SELENA

Yeah.

JC

I think this is something that you've [addressing Seven] told me, on many occasions, which is there's no wonder why all great men spend so much time in solitude. And I only say that because when you're speaking on greatness it's frightening because shock and awe are one and the same even though they're two different concepts. And it doesn't come exclusively. People's initial responses are emotional, you know? And most people don't

even have the ability to have second tier, third tier, fourth tier, fifth tier degrees of thought. So it wasn't even until later on that there were well-articulated responses to this versus the emotional, "kill them," or give them a "crown." And either way, triumph and disaster, is the same posture, I'm not truly interested in that. But the response that got people to close their eyes and look up to themselves, instead of to other people, I think that is a job well done.

KC

And finally . . . how, if at all, has this changed you? And I mean individually or as a crew.

SEVEN

I feel like it was definitely an event that was the end of one thing and the start of another. I think we've all been working on ourselves. And like really working on ourselves. But I feel like it's all starting to pay off, you know? In the long run. I mean it's really strange. Like when I think about why I didn't consider myself a painter, you know? That's really strange. It's the ultimate motivation. I feel it's rare to have inspiration from yourself . . . We did something and we're happy about it. It would have inspired us for the rest of our lives but it went out there and grew and came back. And that's crazy.

JC

Life is work, you know? Life's just work. And you're going to do work. No matter what. You're going to do work. And in life there's ideas and then there's ability. And they're two completely different mountains you have to scale. But it's a completely different bitch once you bridge that gap. You know what I mean, like I can finally paint everything that I can draw, and I can finally draw everything that I can see.

SEVEN

We used to talk about this. We couldn't draw people. We couldn't do it. That's so crazy.

JC

And now I can draw every pore on your damn face, you know.

SEVEN

And that's something we never even thought. I thought like okay we would do good, okay, painstakingly, maybe we have the potential to be able to draw anything once you get there. But like no, you can draw anything.

JC

And that's when I realized those two mountain peaks, those apex had been bridged for myself.

SEVEN

Things just change. I remember I used to be so proud of when people were like, *did you go to school for this*? I was like no. You know, almost snobbishly. Now when people ask, I feel weird. Because I don't want to be that dude anymore but it's something I'm still proud of. Like no, I didn't go to school for this. We taught ourselves. We literally taught ourselves how to paint.

SELENA

I'm with him every day and he's such a good painter and he's so passionate about it. For me, I think it's been more of like, oh, shit, I don't have a passion like that. And then kind of knocking myself for that. But since then, I've realized that's okay, not everyone has a passion like that. I have other things. I don't have to be so finely focused on one thing because I'm really good at a lot of other things that I don't have to spend all of my time doing. And that was really hard for me to realize, you know? I would get really hard on myself for not having something like that because I was with them every day. And I would just be sitting doing something like—you know, not being a master of one thing. But just being. And that's okay. You can do a lot of things. Actually, I have more time to do all the other things, which I kind of like, you know.

KC

On a personal note, at the end of the play, in the play, y'all as characters broke up and y'all—

SEVEN

Yeah, we're *strongly* together now. It's kind of absurd.

KC

Yeah. That's great.

SEVEN

Yeah, a Cinderella story.[1]

1 Days after this interview, as Selena was helping Seven with a major interactive art exhibition in New York, the two got engaged. A Cinderella story indeed.

About the Authors

Kevin Coval is the author of *Schtick, L-vis Lives!: Racemusic Poems, Everyday People, Slingshots: A Hip-Hop Poetica* and is the editor of *The BreakBeat Poets: New American Poetry in the Age of Hip-Hop.* Founder of Louder Than A Bomb: The Chicago Youth Poetry Festival and artistic director of Young Chicago Authors, Coval is a four-time HBO Def Poet and teaches hip-hop aesthetics at the University of Illinois-Chicago. His forthcoming book, *A People's History of Chicago*, will be published in 2017, also from Haymarket Books.

Idris Goodwin is a playwright, rapper, and essayist. He has written numerous plays, including *How We Got On* and *Blackademics*, both of which were nominated for Steinberg Awards. He is the recipient of Oregon Shakespeare's American History Cycle Commission and InterAct Theater's 20/20 Award. Goodwin has developed work with the Kennedy Center, the University of California Santa Barbara's LaunchPad New Play Program and New York University's Tisch School of the Arts Graduate Acting Dept. He has been writer in residence at The Eugene O'Neil Playwrights Center, Berkeley Rep's Ground Floor Program, The Lark Playwriting Center and New Harmony Project. An accomplished Hip Hop poet, his albums include *Break Beat Poems* and *Rhyming While Black,* and he has been featured on HBO, Sesame Street, and the Discovery Channel. Idris teaches performance writing and Hip Hop aesthetics at Colorado College.

About Haymarket Books

Haymarket Books is a nonprofit, progressive book distributor and publisher, a project of the Center for Economic Research and Social Change. We believe that activists need to take ideas, history, and politics into the many struggles for social justice today. Learning the lessons of past victories, as well as defeats, can arm a new generation of fighters for a better world. As Karl Marx said, "The philosophers have merely interpreted the world; the point however is to change it."

We take inspiration and courage from our namesakes, the Haymarket Martyrs, who gave their lives fighting for a better world. Their 1886 struggle for the eight-hour day, which gave us May Day, the international workers' holiday, reminds workers around the world that ordinary people can organize and struggle for their own liberation. These struggles continue today across the globe—struggles against oppression, exploitation, hunger, and poverty.

It was August Spies, one of the Martyrs who was targeted for being an immigrant and an anarchist, who predicted the battles being fought to this day. "If you think that by hanging us you can stamp out the labor movement," Spies told the judge, "then hang us. Here you will tread upon a spark, but here, and there, and behind you, and in front of you, and everywhere, the flames will blaze up. It is a subterranean fire. You cannot put it out. The ground is on fire upon which you stand."

We could not succeed in our publishing efforts without the generous financial support of our readers. Many people contribute to our project through the Haymarket Sustainers program, where donors receive free books in return for their monetary support. If you would like to be a part of this program, please contact us at info@haymarketbooks.org.